IMAGES
of America

LOS ANGELES COUNTY
LIFEGUARDS

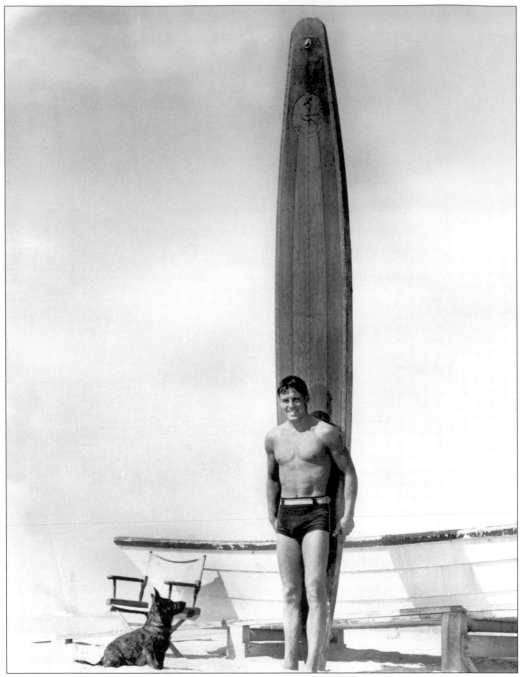

In this 1937 photograph, Lt. Bob Butt can be seen with his paddleboard, as Santa Monica crew mascot "Scotty" looks on. A consummate waterman, Butt would go on to serve as an elite navy frogman in World War II. As a member of the lifeguard-filled Underwater Demolition Team (UDT), Butt cleared mines and other underwater hazards for Allied beach invasions in both the European and Pacific theatres of war.

IMAGES
of America

LOS ANGELES COUNTY
LIFEGUARDS

Arthur C. Verge

ARCADIA

Published by Arcadia Publishing
Charleston SC, Chicago IL, Portsmouth NH, San Francisco CA

Printed in Great Britain

Library of Congress Catalog Card Number: 2005922916

For all general information contact Arcadia Publishing at:
Telephone 843-853-2070
Fax 843-853-0044
E-mail sales@arcadiapublishing.com
For customer service and orders:
Toll-Free 1-888-313-2665

Visit us on the internet at http://www.arcadiapublishing.com

*This book is dedicated to those valiant guards who have gone before,
to those who now serve, and to those who will follow.*

All proceeds for this book go to the Los Angeles County Lifeguard Trust Fund for Public Safety and Education.

CONTENTS

ACKNOWLEDGMENTS

This book could not have been possible without the generous support of the Los Angeles County Lifeguard Trust Fund and the many lifeguards and their families who have donated their photographs for display here. Their unwavering generosity allows you the reader to share in a world of ocean lifeguarding that rarely is seen by the public. This project would not have been accomplished without the support of chief lifeguard Mike Frazer, fire chief Michael P. Freeman, and lifeguard chief Phil Topar. I wish to extend my gratitude to the following: Chief Bud Bohn for starting the collection of lifeguard pictures and memorabilia beginning in the early 1970s and for the work he has done to preserve our organization's history; Chief Dave Story and the Lifeguard Trust Fund for funding every one of my requests to copy lifeguard photo collections (otherwise many of the enclosed photographs would have been lost forever); to ocean lifeguard Dave Kastigar and Venice historian Elayne Alexander for the endless hours they have volunteered in a wide array of activities to preserve the history of ocean lifeguarding in Los Angeles and for all the help they have given to make this book possible; Mr. Hartzell of Hartzell Photography for generously restoring the enclosed photographs; Robbie Rodriquez for a wide array of computer tutoring and assistance with this manuscript; Wendy Stockstill and William E. Doyle for their friendship, hours spent scanning hundreds of lifeguard photographs, and helping me to complete the book's layout; Chief Steve Moseley for a reading and careful editing of the text and photo captions; Mark Verge and Westside Rental Connection for numerous financial donations to aid in the preservation of lifeguard photo collections; to El Camino College librarians Ed Martinez and Jackie Booth for tracking down a wide array of sources pertinent to the history of ocean lifeguards.

And to the following for the sharing of photographs and for endless help with documents and the sharing of oral and written lifeguard histories: John Olguin, Bill Beebe, Will Maguire, Greg Bonann, Bob Sears, John Tabor, Joel Gitelson, Conrad Liberty, Phil Navarro, Nick Steers, Dan Cromp, Marc Wanamaker of Bison Archives, Joe Reinich, Nick Archer, Dave Heiser, Doreen North, Linda Hamilton Hart, Don Wolf, photographer Dwight Ueda, Kathleen McKinley, Art Verge Sr., Bob Walthour, Dick Heineman, Milton Slade, Tim McNulty, Tony Sohn of LAX Photo, Dan Perry, Gordon and Tricia Newman, Matt Lutton, Mr. and Mrs. Steve Harbison on behalf of the Tom Zahn estate, the Shargo family, and the families of lifeguards Morley Gillan, Bob Butt, Pete Peterson, Don St. Hill, Ed Perry, Mickey O'Brien, and Alan "Bud" Lehman.

For their friendship and professional support in all my academic endeavors, I wish to thank Dr. Tom Armstrong, Dr. Kevin Starr, and Dr. Andrew Rolle. I am especially indebted to Dr. Gloria Miranda for her friendship and for all that she has done on my behalf. Words on a printed page cannot express my great love and affection for all of my family: Mom, Dad, Suzanne, Annette, Mark, and Patrick (Here's to many more years in the sand together). I also wish to thank Phil, Cyndi, Casey, and Kelli Topar for being my family in the South Bay. Lastly, I want to thank Dr. Tom Duralde, my primary care physician, and surgeon Dr. Paul Toffel, for giving me my life back.

INTRODUCTION

Ask a visitor exiting a plane at Los Angeles International Airport or a group of young European backpackers stepping off a train at Union Station what they want to see and visit while in Los Angeles and the answer will invariably be "the beach." Ask a native Angeleno to list their favorite things about living in Los Angeles, and certain to be near the top of the list is, again, "the beach." The beaches of Southern California not only serve as the chief recreational area for the region's 10 million residents, but they also have come to symbolize the beauty and uniqueness of the region. Whether it's palm trees, sun-filled wide open stretches of sand adjacent to a crowded bikeway, or the lyrical sounds of The Beach Boys singing the praises of bikini-clad California women and surfing, life along the Southern California coastline has captured the imagination of the rest of the world. Whether they are a visitor, tourist, or resident, each year more than 50 million people take in the sand and the Pacific Ocean on Los Angeles County beaches. As these millions swim, surf, or enjoy catching the rays of a bright Southern California day, they are under the careful attention and watchful eyes of members of the Los Angeles County Lifeguard Service.

The L.A. County Lifeguard Service is the largest and busiest ocean lifeguard service in the world. Open 24 hours a day, 365 days a year, the lifeguard service is responsible for protecting 72 miles of Southern California coastline. Staffed by more than 700 lifeguards, the service has 158 lifeguard towers, 15 substations, and 4 large section headquarters. Aiding the operation are 10 Baywatch rescue boats, and 64 emergency lifeguard trucks. Los Angeles County lifeguards perform more than 10,000 ocean rescues a year. In comparison, ocean lifesavers in Australia perform a nationwide total of 12,000 ocean rescues a year. Los Angeles lifeguards provide over 7,000 medical assists and return over 1,000 lost children a year.

The job of a Los Angeles County lifeguard can be a difficult one. Lifeguards are responsible for handling downed aircraft in the ocean, boat and pier fires, and when necessary, performing ocean and lake recovery operations of deceased victims. Despite those difficult tasks, lifeguards take great pride in protecting the public from an often dangerous and unpredictable ocean. Part of that mission is the popular Junior Lifeguard Program, which teaches and trains over 2,000 youngsters a year. Taught by experienced lifeguards, program participants learn a wide range of safety skills including how to avoid and get out of rip currents, how to properly body and board surf, and how to perform first aid and CPR.

The success of the Los Angeles County Lifeguard Service has attracted substantial media attention. The service has been the subject of the hour-long Turner Broadcasting documentary L.A. Lifeguards and has been profiled in numerous newspaper and magazine articles. The greatest attention brought to the Los Angeles County Lifeguard Service was the television program Baywatch. Conceived by L.A. County lifeguard Greg Bonann (who served as the show's executive producer), it would go on to become the most popular television show in history. With a weekly worldwide audience numbering millions of viewers in 145 countries, Baywatch put the Los Angeles County Lifeguard Service front and center in the realm of

popular culture. The show was named after the service's rescue boats and was filmed on L.A. County beaches using identical towers, uniforms, and equipment. This in turn sometimes led to a blurring of reality and fiction among beachgoers. During the height of the show's popularity, almost every time a county lifeguard appeared on scene to perform a rescue or a medical assist, people would remark, "Oh, good, *Baywatch* is here."

Although the television show was periodically criticized as being unrealistic, it did show a range of unusual problems that lifeguards have to confront. Those include cars being driven off piers, ocean vessels in flames or quickly taking on water, heart attacks in the ocean, rescues in large surf adjacent to rock jetties, despondent beachgoers threatening suicide, etc. As one lifeguard instructor stated during the lifeguard training academy, "When you have 50 million people out there you're bound to have anything and everything happen. Be prepared for it. The only lifeguards who don't have a unbelievable story or two to tell are the ones who have never worked."

This pictorial history offers a rare insight into the work of the Los Angeles County Lifeguard Service. Included are photos of actual rescues, unfolding disasters, as well as historic day-to-day work scenes dating back to 1905. Also included is a wide-range of off-duty photographs, many of which were donated by former lifeguards showing them surfing or enjoying the company of their crewmates at such gatherings as after work luaus.

Ocean lifeguarding in Los Angeles has certainly evolved from its earliest days, when volunteers patrolled the beaches with little training or equipment suitable for ocean lifesaving, but today's modernized and professionally trained L.A. County Lifeguard Service maintains the same primary mission—to detect and rescue those in distress. This book is dedicated to my fellow lifeguards, who, clad only in a red bathing suit, with a rescue can at their side, continue to enter an often dangerous and unforgiving ocean to assist those in their greatest hour of need. May you continue to fulfill your mission so that others may live.

Arthur C. Verge, Ph.D.
Professor of History
El Camino College
Los Angeles County Lifeguard since 1974

One

SO THAT OTHERS
MAY LIVE
1905–1919

The history of the Los Angeles County Lifeguard Service closely mirrors the evolution and development of Southern California. At the turn of the 20th century, much of the area's shoreline was undeveloped and very much underused by Los Angeles residents. Seeking to take advantage of the coastline's exceptional amenities, such as its picturesque scenery and Mediterranean-like climate, early real estate developers Abbot Kinney and Henry Huntington began building their own separate beachside resort communities in 1905. As Kinney built his "Venice of America" and Huntington developed Redondo Beach, both men quickly realized that the growing numbers of ocean drownings in front of their respective communities were sure doom for their expensive real estate ventures. Their problem, though, would be solved by the 1907 arrival of a young Hawaiian by the name of George Freeth. Already made famous by author Jack London, who witnessed and then wrote of his extraordinary skills on a surfboard, the 22-year-old would make a timely appearance on Venice Beach on July 22, 1907. The "Man Who Could Walk on Water," as he became known, would soon be in the employ of both Kinney and Huntington, serving as a swim instructor, lifeguard captain, and founder of their respective volunteer ocean lifesaving services.

Although Freeth died at age 35 during the influenza pandemic of 1918–1919, during his brief life he was the force behind the organizing, training, and equipping of what would evolve into today's Los Angeles County Lifeguard Service.

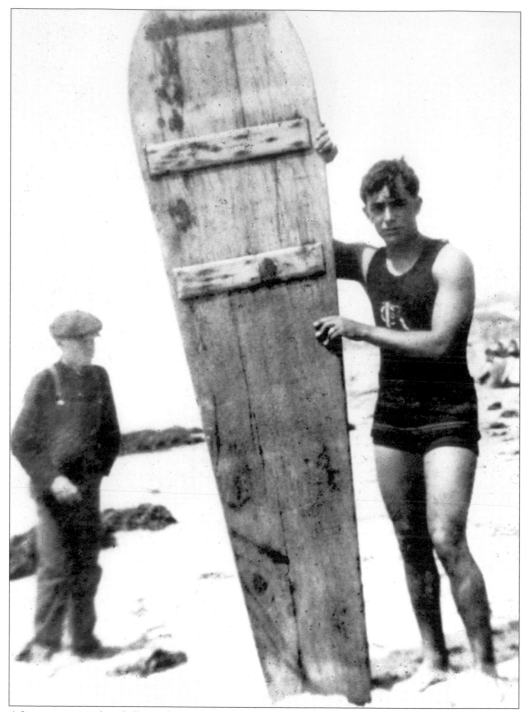

After witnessing his skills in the ocean, renowned writer Jack London made the Hawaiian-born George Freeth world famous. London wrote of Freeth, "He is a Mercury—a brown Mercury. His heels are winged, and in them is the swiftness of the sea." In June 1907, Freeth became the first person to demonstrate the sport of surfing to Southern California. He would also usher in the modern age of ocean lifeguarding.

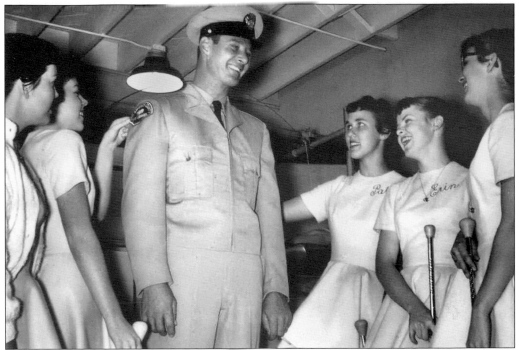

In this 1958 photo, Bud McKinley is warmly greeted as he proudly displays his new Los Angeles County Lifeguard uniform.

Prior to the implementation of professional lifeguard services, bathers who dared to venture into the ocean often used "lifelines" to keep themselves safely close to shore. Unfortunately, the lifelines proved deceptively dangerous, and those relying on them did not take into account the strength and power of large waves and rip currents, thus making "accidental drowning" a common form of death along the Southern California coastline.

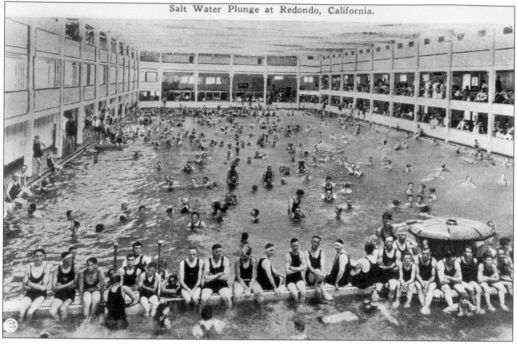

Salt Water Plunge at Redondo, California.

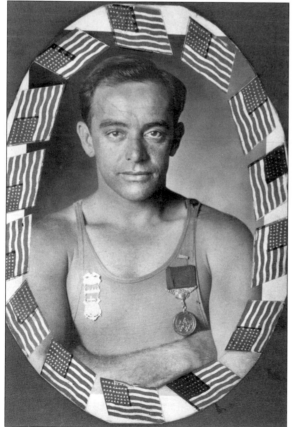

Both Abbot Kinney of Venice and Henry Huntington of Redondo built large saltwater plunges to give bathers a feel of swimming in the ocean without its dangers. Freeth worked for both men, serving as a swim instructor and a plunge and ocean lifeguard. Many of his hours were spent teaching and coaching youngsters in the sports of water polo and competitive swimming.

On December 16, 1908, Freeth led a rescue effort that saved the lives of 11 Japanese fishermen at Venice Beach. In the cold and stormy ocean for over two and half hours, Freeth was personally responsible for saving seven lives. For his heroism, he was awarded both the U.S. Volunteer Life-Saving Medal for Valor and, by an act of Congress, the Congressional Gold Medal.

As attested by this signed 1910 photograph, Freeth was well-known by the beachgoing public for his abilities in the water. A world-class swimmer, high diver, rower, and water polo player, Freeth was known as the "Man Who Could Walk on Water" for his skills on a surfboard. So popular was Freeth that when he once took ill from a bout of food poisoning, it made the local newspapers.

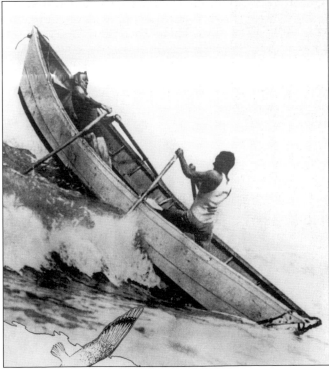

As part of his physical conditioning, Freeth enjoyed rowing a quarter-ton dory through the surf. In this 1913 photo shot at Redondo Beach, Freeth leads the bow while a fellow Redondo Beach lifeguard helps to steer the boat.

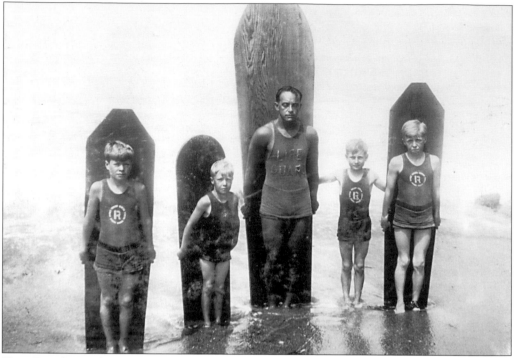

Here, Freeth stands with several of his young proteges, all of whom are in the process of learning to become well-rounded watermen. Not only would these young Redondo boys become some of California's first pioneer surfers, they would also go on to form the nuclei for Los Angeles's three modern ocean lifeguard services.

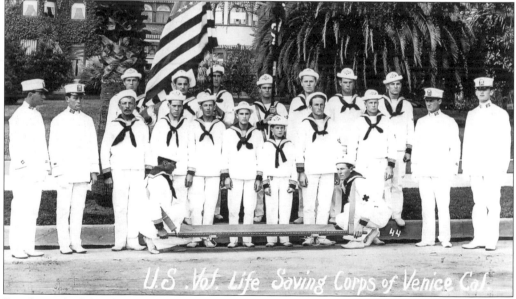

U.S. Vol. Life Saving Corps of Venice Cal.

Freeth worked hard to organize and train volunteer lifeguards to patrol local Los Angeles beaches. Here he stands, at the far left, in his captain's uniform reviewing the 1909 U.S. Volunteer Life Saving Corps of Venice. Freeth also successfully organized the Redondo Beach Life Saving Corps.

14

When not lifeguarding or teaching swimming safety, George Freeth often took to the water to enjoy the sport he made popular. In this 1909 photo, he is seen surfing off Hermosa Beach.

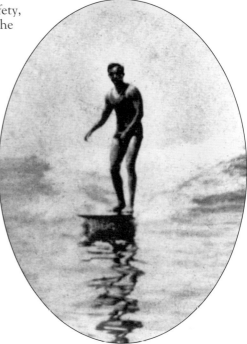

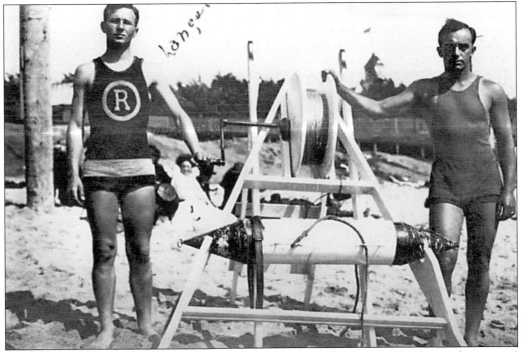

Ever the innovator, George Freeth designed and patented a life-saving reel device that proved effective on area beaches. Here, Freeth stands with Ludy Langer, whom he trained and coached to a world record in the 800-meter freestyle. After returning home from World War I, Langer would win a silver medal in the 1920 Olympics. The roof of the old Redondo Beach Hotel can be seen in the background.

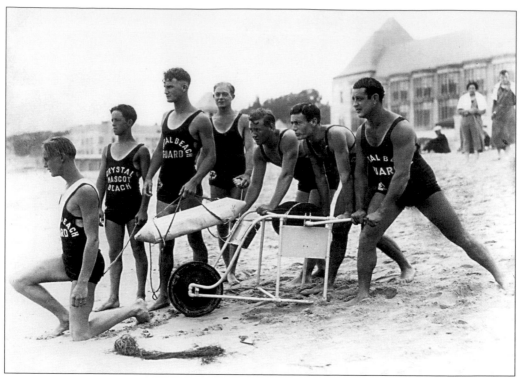

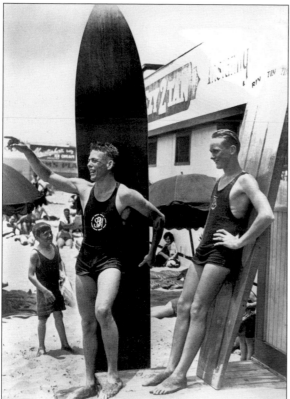

A legacy of George Freeth was renowned waterman Pete Peterson, seen kneeling at the ready as a young member of the Crystal Beach lifeguard crew, which once patrolled the southern end of Santa Monica Beach. Peterson, known as "Iron Man" by the Santa Monica Lifeguard Service, was a longtime champion ocean competitor. He would go on to invent the still widely used Peterson rescue tube.

Despite Freeth's passing in 1919, the sport of surfing had taken a firm hold along the Southern California coastline by the late 1920s. Pete Peterson, seen leaning on his surfboard, would be a four-time winner of the Pacific Coast Surfing Championships. Thirty-four years after his first Pacific Coast Championship victory, he would become a surfing icon by winning the tandem division at the 1966 World Surfing Championships.

Two

THE JAZZ AGE HITS THE SAND

1920–1929

In the wake of World War I and the equally devastating flu pandemic of 1918–1919, there was an emphasis among Americans during this boom decade of the 1920s to live for today and not worry about the future ("for who knows what tomorrow will bring"). The rise of a bustling economy, a relaxation of Victorian sexual attitudes, and the introduction of Henry Ford's affordable Model T automobile brought dramatic changes to the beaches of Southern California. Chief among them was the tremendous growth in beach use and attendance. The growing popularity of the beaches led to the creation of both the Los Angeles City and Los Angeles County Lifeguards Services.

Lifeguard Morley Gillan, who worked for both services, recalled that during the 1920s, "the beach was the place to be." Among his favorite memories was getting off work and heading over with fellow lifeguards to dance pavilions that were located on nearby piers. There they would dance with girls from all over Southern California. It was there he met his wife of over 60 years. Another lifeguard recalled the temptations caused by Prohibition-era gangsters who would try to bribe lifeguards to look the other way when they would attempt to smuggle booze from offshore speedboats up on to the beach at night. Asked if he ever partook in such an offer, he replied, "No, 'cause I knew if the gangsters didn't kill me, my mom would."

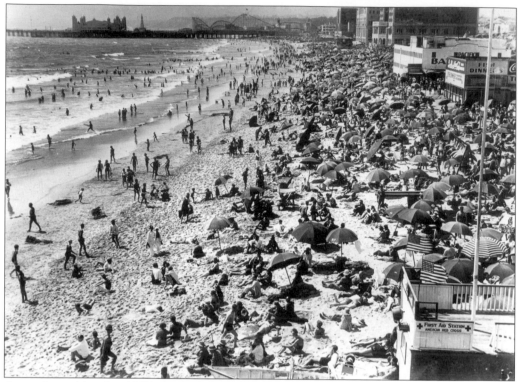

As evidenced by this 1927 photograph, the beach in the 1920s had become the place to be. With the Santa Monica Pier in the far background, the local volunteer lifeguard headquarters can be seen in the bottom right corner.

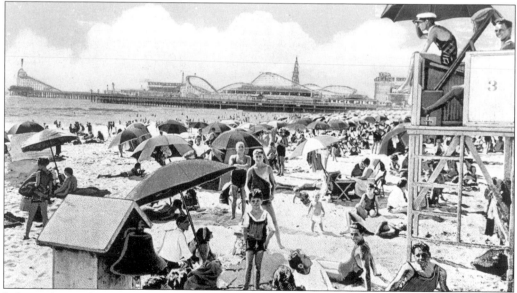

Lifeguards watch over crowds at neighboring Venice Beach with the Ocean Park/Lick Pier in the background. When lifeguards were not on duty, the bell, seen in the left corner, was rung to signify that someone was drowning. Lifeguards living in neighboring apartments or working in local businesses would drop everything and rescue the victim.

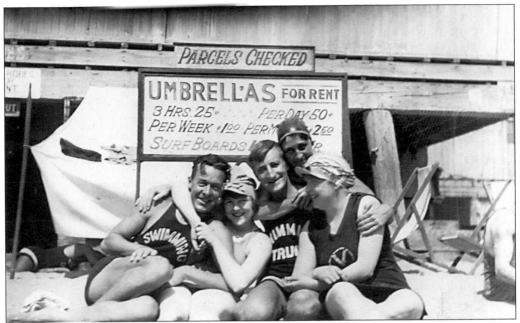

Echoing the words of F. Scott Fitzgerald's ode to the 1920s, "Ain't we got fun," are two Venice swim instructors who doubled as ocean lifeguards. The sign in the background advertises the renting of surfboards, signifying the sport's growing popularity.

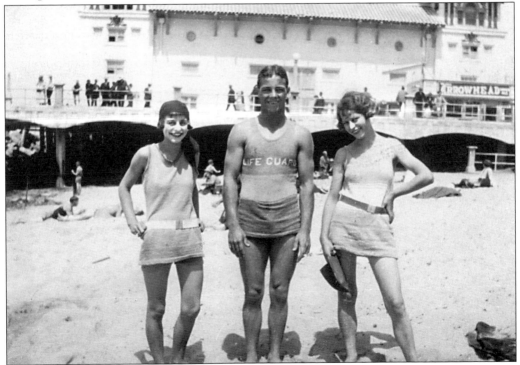

Taken just south of the Redondo Beach Plunge, this photo shows two very pretty and stylishly outfitted, flapper-era beachgoers posing with the local lifeguard. Just as back then, lifeguards today have a difficult time complaining about their work conditions.

Courtesy of Linda Hamilton Hart, the 1924 photo above left shows her father, Fenton Hamilton (on the right), with his friends Marie and Waite. The lettering of the Cadillac Hotel, which still stands behind the Rose Avenue lifeguard tower in Venice, can be seen in the background. In the photo above right, Hamilton enjoys playing the ukulele as Waite and off-duty guard Phil Daubenspeck look on. The playing of the ukulele was, and still remains, a lifeguard tradition dating back to the service's early ties with Hawaiian watermen George Freeth and Duke Kahanamoku.

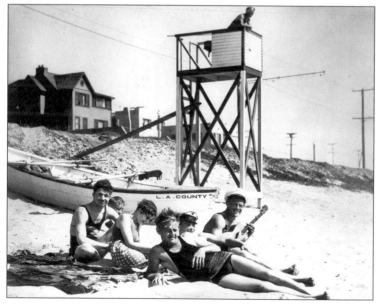

While their colleague watches over the beach, several off-duty Los Angeles County lifeguards enjoy a warm summer day with friends on Manhattan Beach. One guard is playing the ukelele.

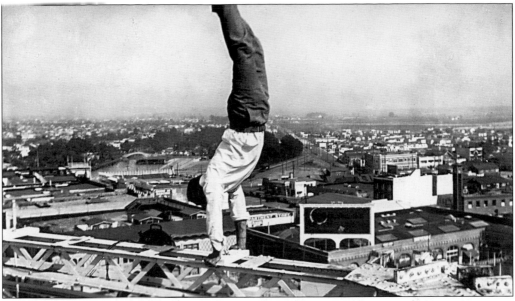

Like several of his lifeguard colleagues, Fenton Hamilton was also a skilled gymnast, as proven by this 1925 photograph of him atop the Venice Flying Circus ride.

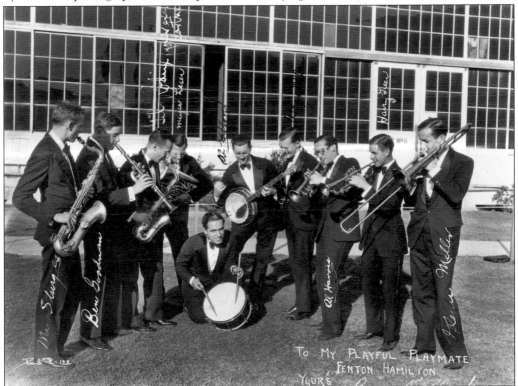

When not lifeguarding, Hamilton helped open and close the popular Venice Ballroom. In gratitude for his work and friendship with the beachgoing band members, Hamilton received this hand signed photograph from Ben Pollack and the Californians. Included are signatures of bandmates Benny Goodman (second from the left) and Glenn Miller (far right).

Pictured here is Fenton Hamilton at work, as a fellow lifeguard joins him up on the stand. At the bottom, attached to a large nail, is Hamilton's metal rescue can.

By the 1920s, ocean swimming was the rage among the beachgoing public. Here, Venice lifeguard Elmer Orr stands behind his swimming pupils. So popular was swimming that contests were frequently held—the most popular being a well-publicized, long-distance swim race between the mainland and Catalina.

Lifeguard Wally O'Connor was a four-time Olympian. As the American team captain and flag bearer in the 1936 Olympic games, O'Connor created a fury in Germany for his refusal to dip the American flag toward the viewing stand that contained "host" Adolph Hitler. Later hailed as an American hero, O'Connor would be among the first of more than 45 Los Angeles lifeguards who have competed in the Olympic games.

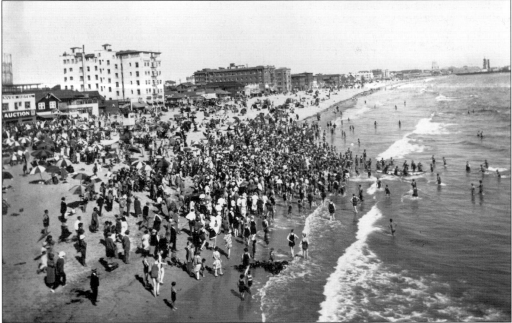

At a 1925 beachside wedding officiated by well-known radio preacher Sister Aimee Semple McPherson, lifeguards were called to rescue two victims trapped in a large rip current. A news photographer caught the crowd surging towards the lifeguard dory as it returned to the beach with its victims.

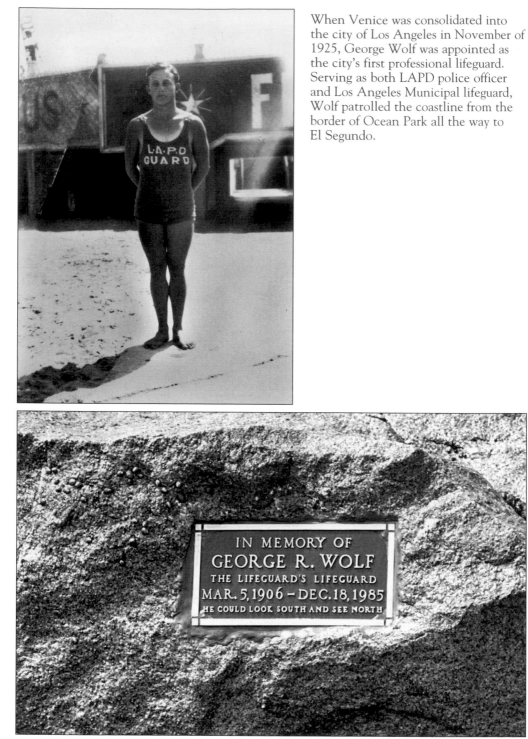

When Venice was consolidated into the city of Los Angeles in November of 1925, George Wolf was appointed as the city's first professional lifeguard. Serving as both LAPD police officer and Los Angeles Municipal lifeguard, Wolf patrolled the coastline from the border of Ocean Park all the way to El Segundo.

Following Wolf's passing in 1985, lifeguards placed this memorial plaque on the Venice Breakwater. Wolf was known for his outstanding eyesight, and an innate sixth sense of a knowing when a swimmer was in trouble.

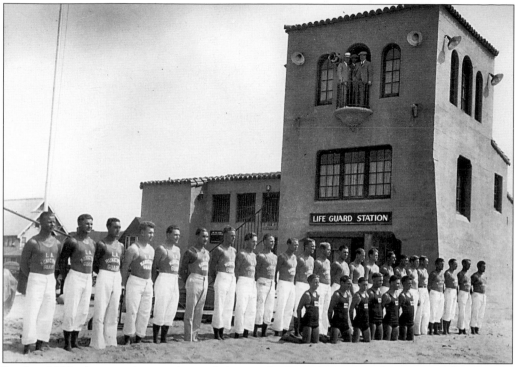

In this 1927 photograph, members of the newly formed Los Angeles Municipal Lifeguard Service stand at attention in front of their new Brooks Avenue station in Venice. In front are the crew's junior lifeguards, who were organized and trained by lifeguard Bob Foster.

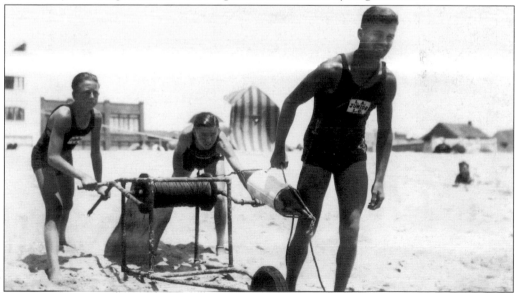

The Los Angeles Municipal Guard Service created the first formal Junior Lifeguard program in 1927. Pictured here are, from left to right, Ed Perry, Jack Phen, and Lawrence McNulty. McNulty became an ocean lifeguard. His son Tim Sr. and grandson Tim Jr. also continued the tradition. Ed Perry became a legendary lifeguard boat skipper. His son Dan also served as a lifeguard.

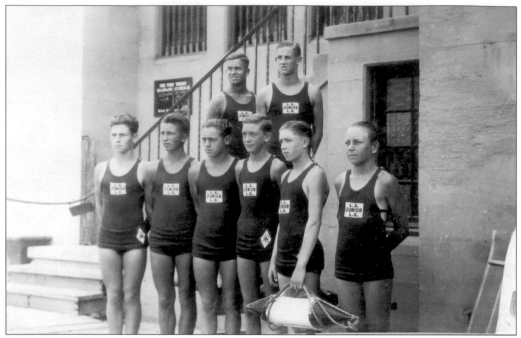

Posed together behind the Brooks Avenue Station are the inaugural members of the Los Angeles City Junior Guard program. Pictured, from left to right, are (front row) John Logham, Bob Crownover, Harry Snyder, Cliff Henderson, Jack Phen, and Ed Perry; (back row) Lawrence McNulty and Ward McFadden.

Ed Perry was a fixture on Venice Beach for over 80 years, earning the proud nickname "The Admiral" for his many years of service as a lifeguard rescue boat skipper. As he sits in his dory, "The Admiral" is surrounded by a group of young extras from the television show *Baywatch*.

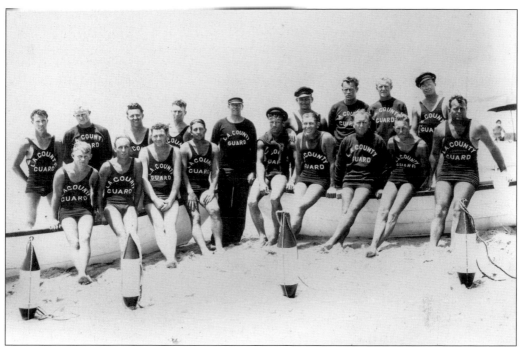

With metal cans and dories at the ready, the newly formed Los Angeles County Lifeguard Service takes it place. Officially inaugurated in 1929, the service would patrol and protect a wide range of beaches extending up and down the Southern California coastline.

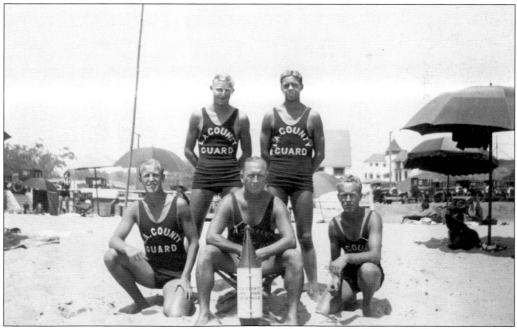

Among the first beaches guarded by Los Angeles County Lifeguards in 1929 was Santa Monica Canyon, the site of Southern California's first beach resort (1887). Among the first L.A. County lifeguards assigned to work there was George "Cap" Watkins (not pictured) who would later become the first chief lifeguard of the Santa Monica Lifeguard Service.

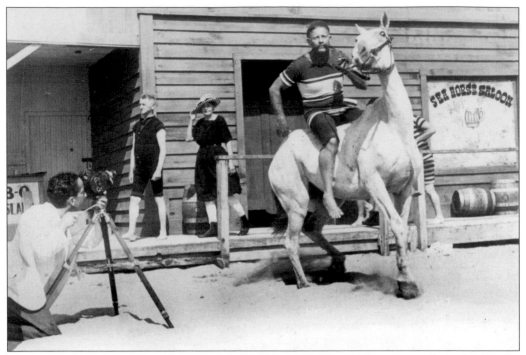

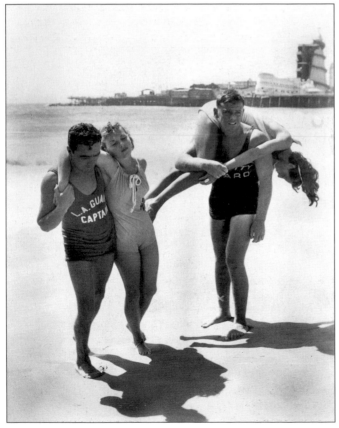

When not working the beach as a lifeguard, George "Cap" Watkins supplemented his income by working as a stuntman during the silent-movie era. A skilled equestrian and diver, Watkins was among the first of many lifeguards to find plentiful work in the burgeoning film industry.

As part of their campaign to increase tourism to the region, the Los Angeles Chamber of Commerce used staged photographs such as this one to promote the fact that professional lifeguards were employed along area beaches. With a flair for the dramatic, the two models are being escorted to safety by two lifeguards.

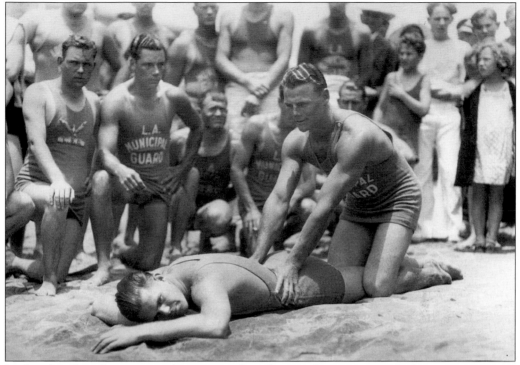

In this chamber of commerce photo, a guard can be seen demonstrating the latest way to revive a swimmer who had taken in too much water. Notice the carefully styled hair of the lifeguards.

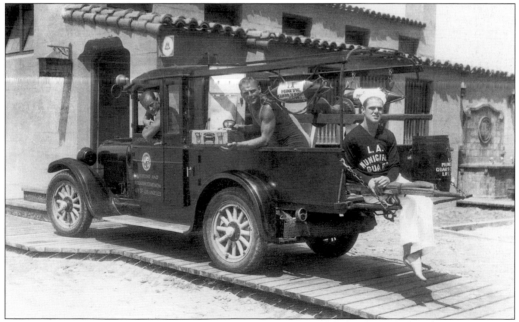

Important in advertising the work of the lifeguard service were photos showing the guards with their equipment. Just as the automobile age was sweeping over the Southland, lifeguards are seen with their new lifeguard truck, complete with a modern resuscitator (seen open in the center of lifeguard truck).

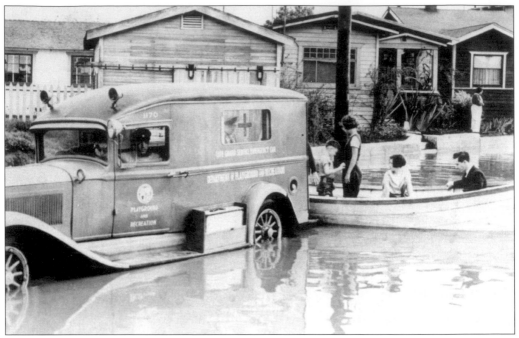

In this 1934 news photo, Los Angeles City lifeguards are shown using their emergency vehicle and a beach dory to evacuate flood victims in Venice. Los Angeles County lifeguards also traveled as far as the San Fernando Valley to assist rescue efforts in both the 1934 and 1938 floods.

Honorary bathing beauty judge and Venice lifeguard captain Myron Cox poses with the newly chosen Miss Venice. Cox would serve as chief lifeguard for the Los Angeles City Lifeguard Service for a record 42 years.

Three

THE BEST OF TIMES, THE WORST OF TIMES
1930–1945

The stunning collapse of the American economy in late 1929 caused millions of Americans to lose their jobs. Employment opportunities for lifeguards, however, actually increased, as record numbers flocked to area beaches to help take their minds off the economic hardships being suffered.

In response to the increasing numbers of visitors to its beach, the Santa Monica Lifeguard Service was founded in 1932. As with both the Los Angeles City and L.A. County Lifeguard services, the Santa Monica Service became a beneficiary of Pres. Franklin Roosevelt's New Deal. Under the WPA (Works Progress Administration), new permanent lifeguard stations and portable wooden towers were built.

The financial difficulties brought forth by the Great Depression, however, led South Bay cities Torrance, Redondo, Hermosa, and Manhattan Beach to request that their services be consolidated into the Los Angeles County Lifeguard Service. As the mergers were completed, the "Big Three" began organizing popular nighttime competitions that showcased the lifeguard service's ability to swim, paddle, and row through the ocean.

Just as the Depression was beginning to recede, it was replaced by the onset of the Second World War. Following the attack on Pearl Harbor, the lights of area piers that once shone over the ocean competitions were turned off, as all of Los Angeles went under wartime blackout conditions. Area beaches, too, soon became off-limits, both as a security precaution and because the lifeguards themselves began shipping out for military service.

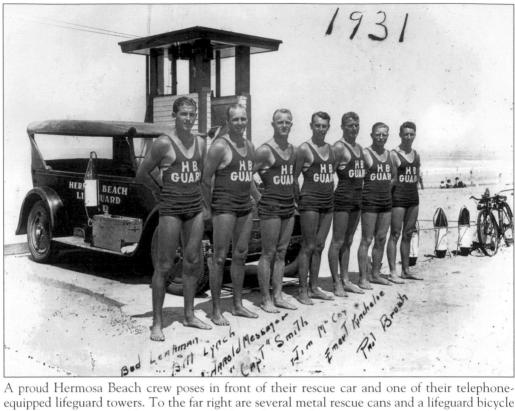

1931

Bud Leahman ... Bill Lynch ...Harold Messenyen "Capt" Smith -Jim McCoy Ernest Kincheloe Paul Brush

A proud Hermosa Beach crew poses in front of their rescue car and one of their telephone-equipped lifeguard towers. To the far right are several metal rescue cans and a lifeguard bicycle that was used to respond to emergencies along the strand.

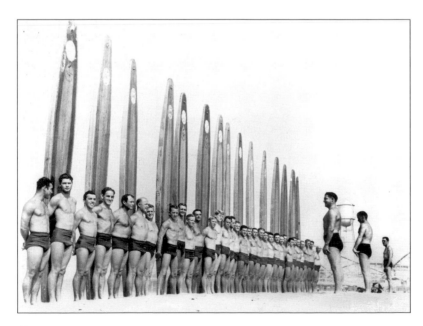

In this August 1936 photo, Los Angeles City lifeguards pose for inspection in front of their new paddleboards.

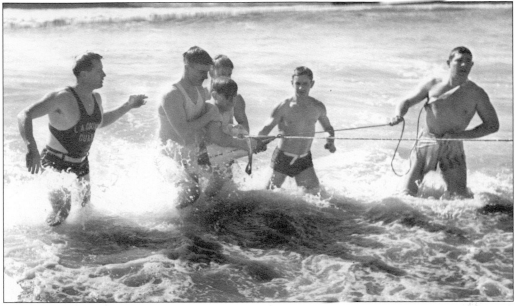

The need for speed and strength can be seen in this photo of an actual ocean rescue that took place at Hermosa Beach in 1936. Making the rescue are, from left to right, county lifeguards Chuck Sumner, Bob Rodecker, and Bill Hoffman.

The continuing growth and popularity of Los Angeles beaches during the Depression necessitated the need for round the clock lifeguard operations. Here, Frank Rodecker is seen working the night shift at Redondo Beach headquarters.

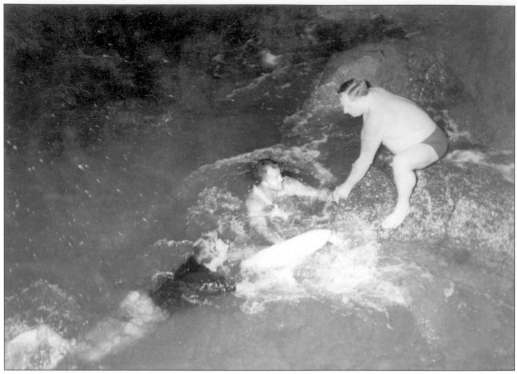

Frank Rodecker (in the water) and fellow county lifeguard Jim Neves rescue a man who attempted suicide by jumping off from the nearby Redondo Beach Pier.

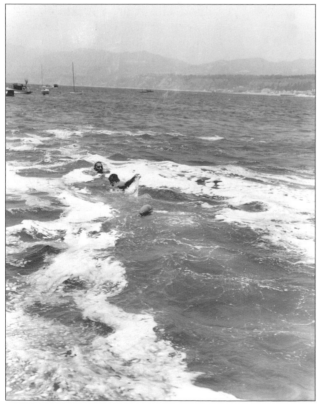

In this 1937 photo, a Santa Monica lifeguard races to the aid of a man trapped in a rip current just north of the Santa Monica Pier.

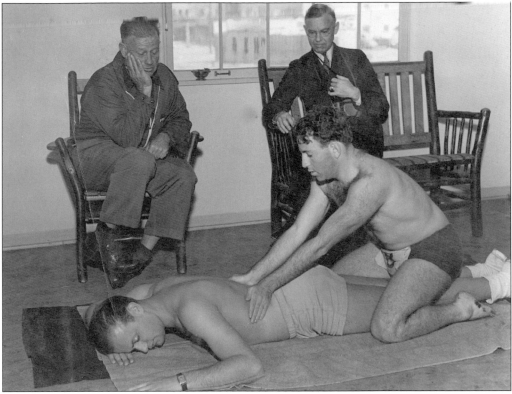

As examiners watch, lifeguards practice a very outdated resuscitation technique. Lifesaving resuscitation would greatly improve during the Depression with the introduction of new equipment and techniques.

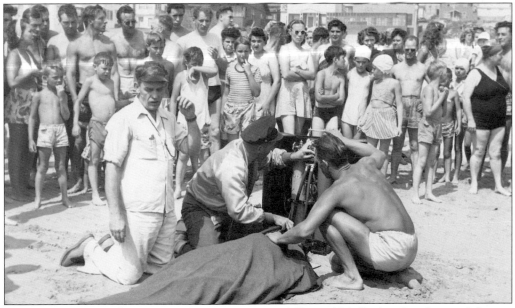

In this July 7, 1941 photo, Gus Edgar, Joe Potts, and Howard Mollenkopf work to stabilize an injured beach patron.

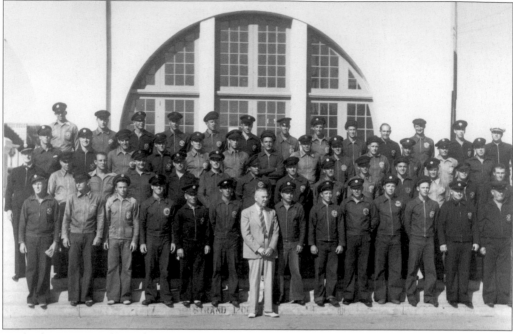

With the merger of South Bay city lifeguard services now completed, members of the Los Angeles County Lifeguard Service pose together in this Depression-era photo.

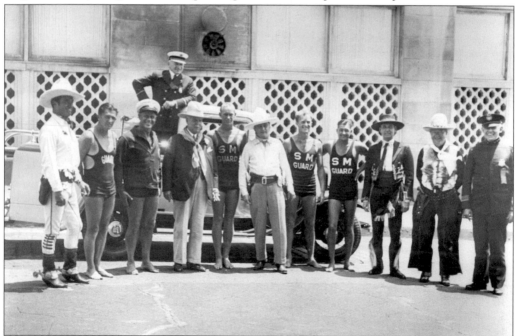

Recalling the city's Spanish speaking heritage and history, Santa Monica lifeguards pose with actor Leo Carrillo (center in white hat and shirt), as part of a Mexican Fiesta Day celebration. Carrillo, who played the "Cisco Kid" in movies and on television, was a champion ocean distance swimmer and an original Santa Monica Beach Club lifeguard. Several lifeguards, including L.A. County chief Ed Carroll, spoke fluent Spanish.

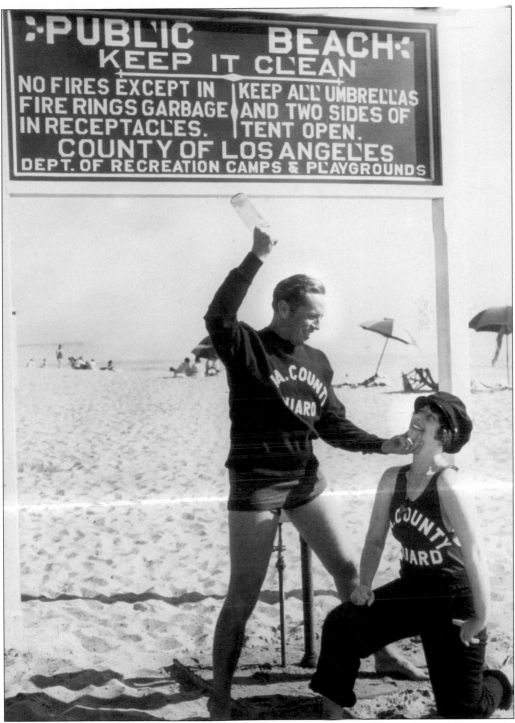

Here, chief lifeguard Ed Carroll is seen "christening" Helen "Skippy" Raymond as L.A. County's first female lifeguard in May 1930. Ms. Raymond worked as a swim safety instructor at Santa Monica Canyon (also known as "State Beach") for women interested in ocean swimming and beach safety.

In this 1931 photo, several pioneer members of the Los Angeles City Lifeguard Service gather in front of the old Venice Headquarters. Pictured, from left to right, are (front row) George Wolf, Nick Lutz, and Myron Cox; (back row) Reggie Harrison, Bob Foster, Bing Hedberg, Leo Cronin, and Blair Ross.

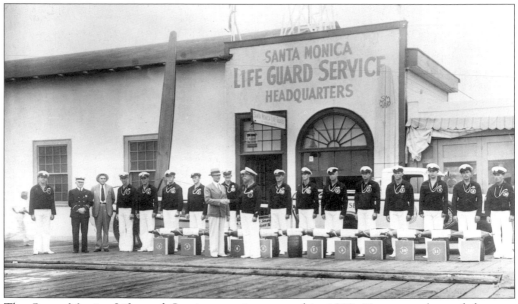

The Santa Monica Lifeguard Service was inaugurated in 1932. Here, members of the new service receive congratulations from Santa Monica mayor William Carter, who is seen shaking the hands of Santa Monica lifeguard chief "Cap" Watkins.

Affectionately known as "Cap" by all who
knew him, Chief George Watkins played
water polo with George Freeth and was
one of the first Los Angeles County
lifeguards. Watkins had among his many
close friends California governor Earl
Warren. He would serve for more than
two decades as chief lifeguard for the City
of Santa Monica.

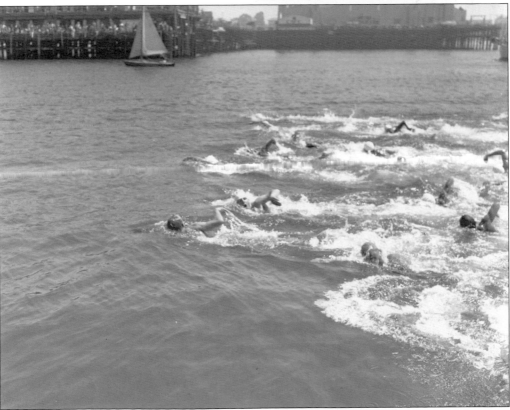

During the Depression, jobs were hard to come by, as attested by this competitive 1937 ocean
lifeguard test off the Santa Monica Pier. In this case, just five of the fastest swimmers in the mile
race were selected to become lifeguards.

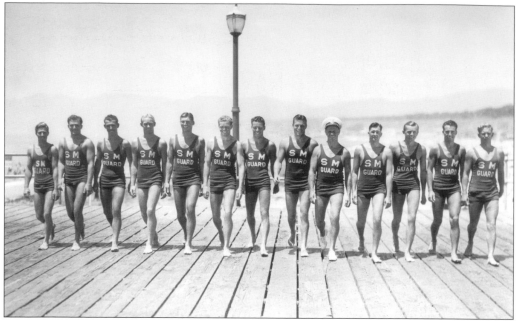

Members of the 1932 Santa Monica crew walk toward the camera on the Santa Monica Pier. To the left of "Cap" Watkins (who is wearing his chief's hat) is swimming legend and honorary Santa Monica lifeguard Buster Crabbe.

Part of Pres. Franklin Roosevelt's New Deal public works program was the building of the Santa Monica Breakwater. Here, assisted by pretty bathing-suit models, "Cap" Watkins undrapes the American flag.

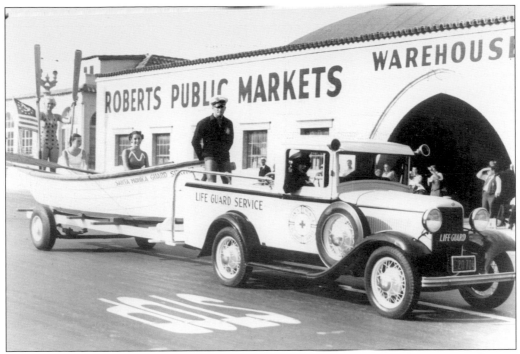

As part of the celebration of the completion of the new breakwater in the summer of 1934, Santa Monica lifeguards joined the civic parade along the city's Broadway Street.

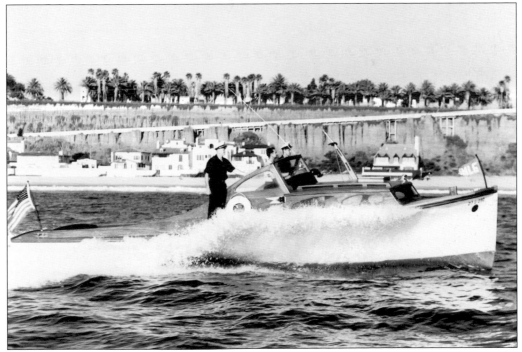

Flying the pennant of the Santa Monica Lifeguard Service, "Cap" Watkins, Los Angeles County lifeguard Herb Barthels, and Santa Monica skipper Pete Peterson test the service's new lifeguard boat.

Pictured is the "El Salvador," Los Angeles City's first lifeguard rescue boat. Built as part of the Depression-era Works Progress Administration (WPA), the boat and its crew communicated with each other through hand signals and a voice tube located in a pole above the bow. Skipper Blair Ross is seen next to the voice tube helping to visually guide the helmsman.

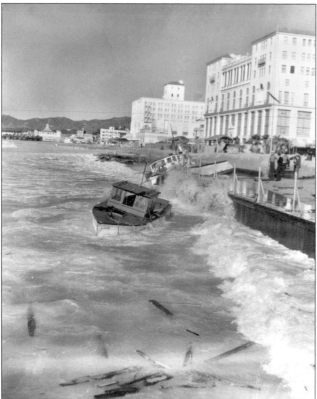

Even with a newly built breakwater, powerful winter storms were often responsible for pulling boats from their Santa Monica Harbor moorings and depositing the wrecks up and down the shoreline.

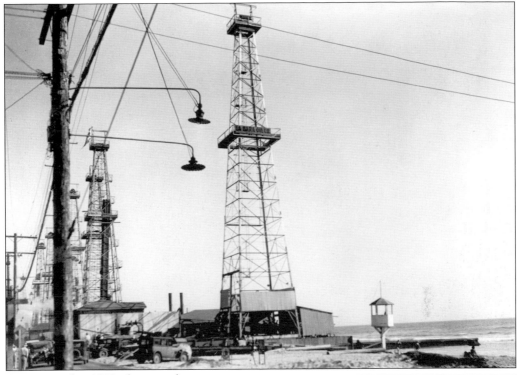

As seen in this 1932 photograph, tower comfort for lifeguards was not a high priority during the Depression. The stand, which was located just south of Washington Boulevard in Venice, stood in the shadow of oil derricks that dotted the whole of today's southern end of Venice Beach.

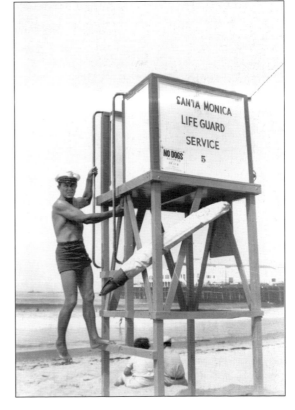

Santa Monica lieutenant Bill North, seen in this spring 1942 photograph, stands astride one of the Santa Monica lifeguard stands that lifeguards derisively referred to as "penalty boxes." The stands were later replaced by large wooden towers that afforded lifeguards protection from the sun and inclement weather conditions.

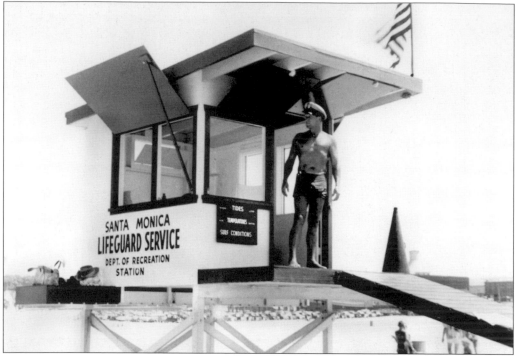

Here, Lieutenant North is seen standing on a brand new 1952 tower. Wood towers proved to be temperate in the summer and warm in the winter allowing lifeguards to work comfortably year round. In 2002, under the leadership of Los Angeles County lifeguard chief Mike Frazer; all county towers were replaced with brand new lifeguard designed stations.

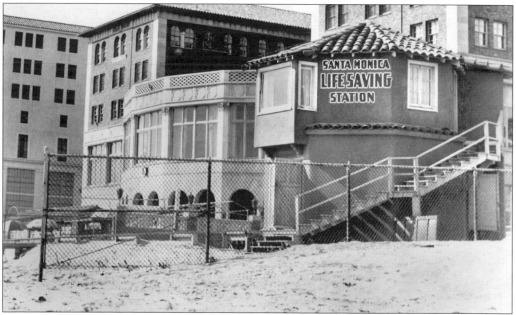

Santa Monica's first main lifeguard station located on the beach was one block south of Pico Boulevard directly adjacent to today's popular Casa Del Mar Hotel. The original Casa Del Mar, seen in the background, was a popular beach club particularly in the late 1920s.

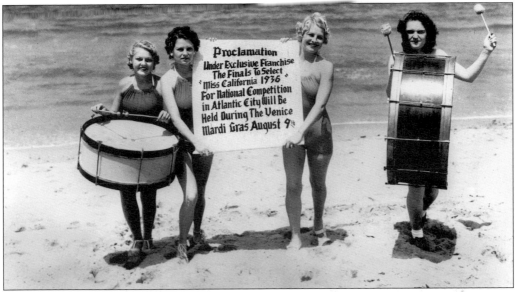

To help ease people's minds during the Depression and to help encourage visitors to come to Venice, Mardi Gras was held throughout the city. Backed by the scenic shoreline, bathing-suit-clad models advertise the upcoming event.

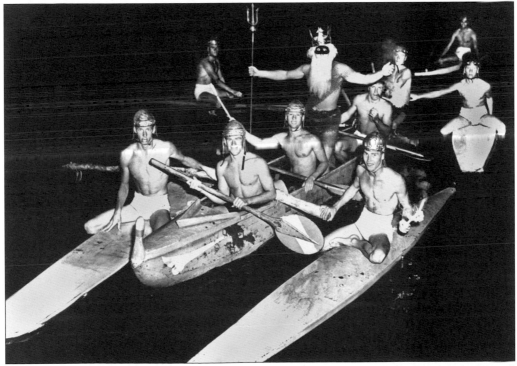

In this 1936 night photo, lifeguards escort King Neptune to the Venice Pier, where he will preside over the evening's festivities. One year, L.A. City lifeguard chief Myron Cox, who was playing King Neptune, nearly drowned when he slipped going up a pier ladder and fell into the ocean. Although he was weighted down by a heavy metal costume, fellow lifeguards and Cox's own physical strength kept him afloat until he could be safely lifted out of the water.

Although lifeguard budgets were tight during the 1930s, lifeguards became increasingly mobile along the coastline with well-equipped rescue trucks. Sunset Pier was located on Venice Beach.

In 1948, guards Nate Shargo and Cal Porter posed with their 1933 Ford Lifeguard Rescue truck—a relic at the time. Both recall attempting to race to emergencies with the rescue vehicle's lights and siren on, only to have the aged truck passed by every car on the Pacific Coast Highway.

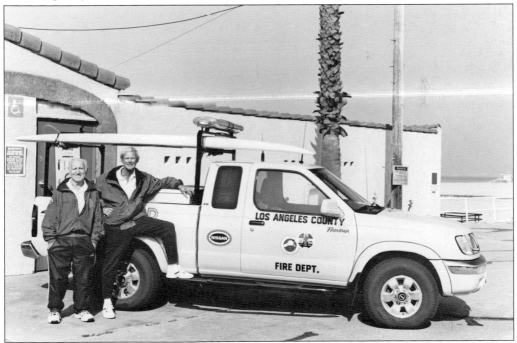

In 1999, lifeguard chief Bud Bohn posed lifeguard alumni Nate Shargo and Cal Porter back together at their former Santa Monica Canyon station, but this time with a lifeguard truck that could effectively race to emergencies. (Courtesy of Ann Anderson Photography.)

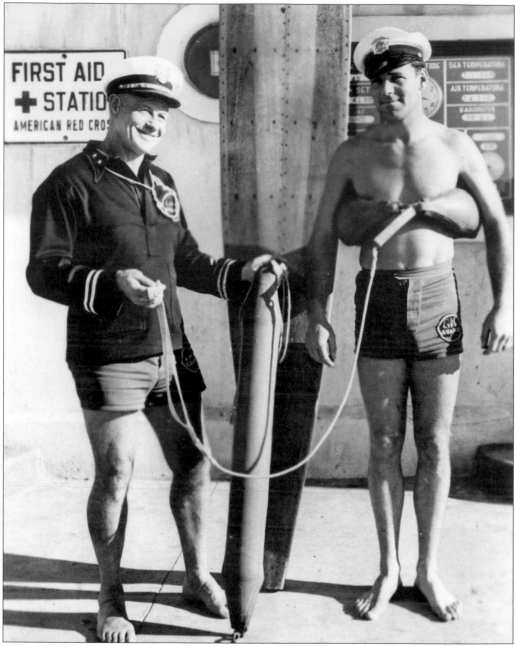

Santa Monica lifeguard chief "Cap" Watkins and Capt. Bob Butt demonstrate to the press the new neoprene rescue tube. Invented by Santa Monica guard Pete Peterson, the rescue tube remains in worldwide use today.

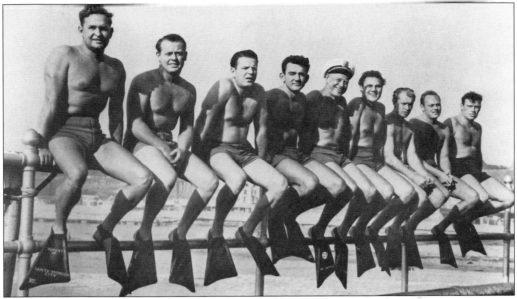

In 1938, Owen Churchill presented members of the Santa Monica Lifeguard Service with his newly designed swim fins to aid them in their ocean rescues. Churchill's fins would quickly be adopted by the United States military during the Second World War for undersea operations.

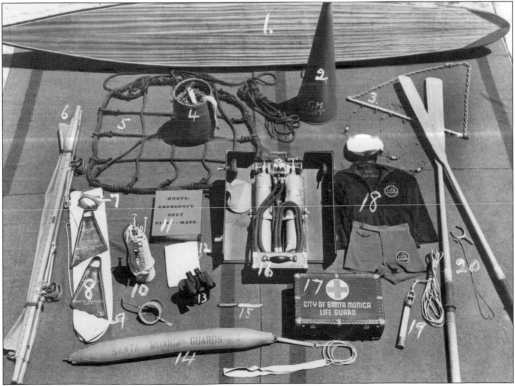

Santa Monica lifeguard Bob Sears took this 1938 photo. It was distributed in newspapers throughout the nation to show the American public the array of equipment lifeguards used in their work on the beach.

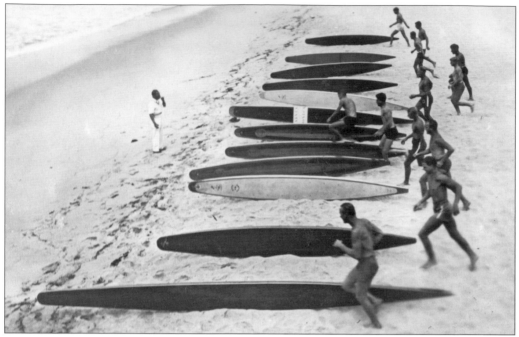

During the Depression, lifeguard competitions between the three Los Angeles area lifeguard services became a popular spectator sport with the main competitions being held at night near the Hermosa Pier. Pictured is the start of a 1932 daytime paddleboard race.

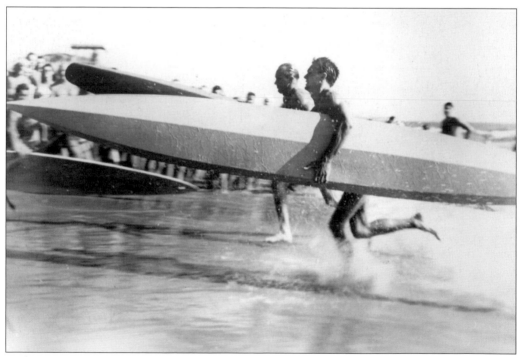

In this 1937 paddleboard competition photo, Pete Peterson (in the middle center) races up the beach. It was not uncommon for competitors to use 14-foot boards in their races.

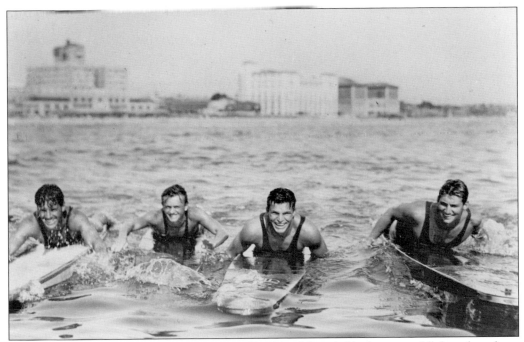

Olympic swimming gold medalist Buster Crabbe (third from left) enjoys a paddleboard workout with members of the Santa Monica lifeguard crew. As part of his physical training, Crabbe would swim every morning from Santa Monica Canyon to the Santa Monica Pier and back— approximately four miles.

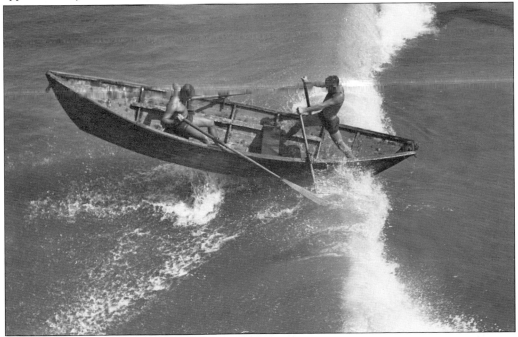

In this 1935 photo, county lifeguards Ralph Zwolzman and Herb Barthels prepare for an upcoming dory race. Barthels, in the aft section of the dory, was a member of the United States Olympic water polo team in 1936.

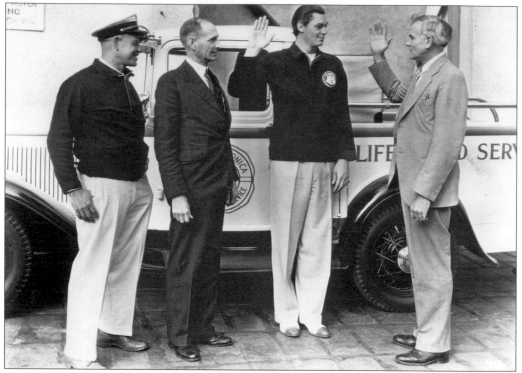

A popular fixture on the beach and at lifeguard functions was Johnny Weissmuller. Known to the moviegoing public as "Tarzan," Weissmuller was better known to the sports world as the greatest swimmer in history. In his seven years of competition, Weissmuller never lost a race and set the unmatchable feat of 67 world records. In 1932, he was made an honorary Santa Monica lifeguard.

Despite Weissmuller's celebrity status, he spent much of his free time working out and training with local lifeguards. In this photo, Weissmuller is seen in his honorary Los Angeles County lifeguard uniform with Lt. Don St. Hill. When not making movies, Weissmuller would often volunteer his time to coach youngsters interested in becoming ocean lifeguards.

Another Hollywood celebrity and Olympic gold medalist swimmer who enjoyed working out with L.A. County and Santa Monica lifeguard crews was Buster Crabbe. He is pictured here in 1936 after being sworn in as an honorary Santa Monica lifeguard. Crabbe, like Weissmuller, had a lengthy movie career and was best known for his roles as Flash Gordon and Buck Rogers.

Here, Crabbe is seen with lifeguard Lt. Don St. Hill as they enjoy an afternoon lifeguard crew sail off the South Bay coastline. Crabbe was used in publicity photographs to show how lifeguards make rescues.

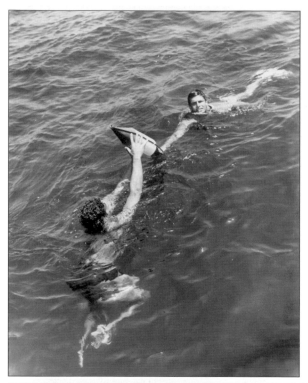

Crabbe demonstrates how a lifeguard safely hands a rescue can to a swimmer in distress. Photos such as these were sent to newspapers and magazines to show the work lifeguards do to make beaches safe for those venturing into the ocean.

During the Depression, lifeguards often supplemented their incomes by working as stuntmen in the movie industry. Here, off-duty members of the Santa Monica and Los Angeles County crews pose with actor Freddie Bartholomew in the 1938 movie *Lord Jeff*.

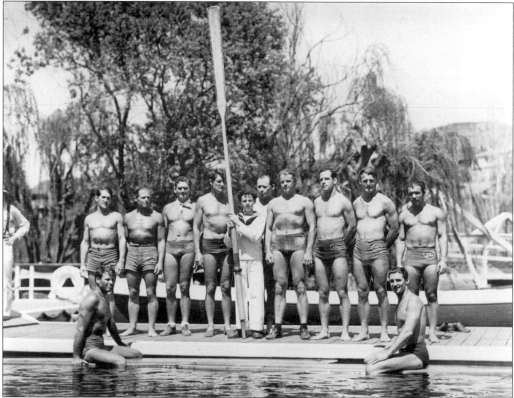

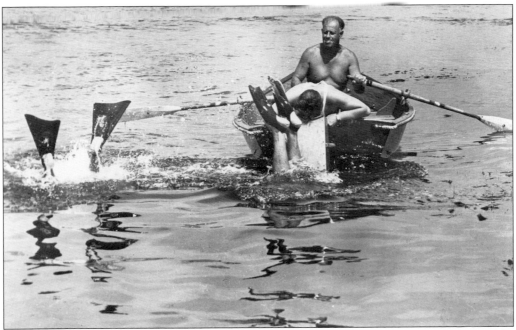

Among the favorite activities of off-duty lifeguards was diving for lobster that would be used for large evening luau celebrations. Here, "Cap" Watkins rows a dory as fellow lifeguards dive for that evening's dinner.

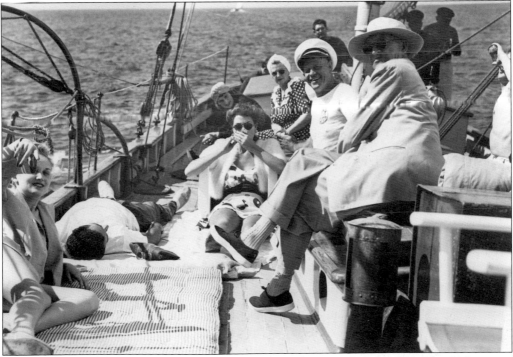

Sailing back for an evening luau are "Cap" Watkins and various friends of the lifeguard service. Among those who enjoyed the parties at Watkin's Malibu home were Gov. Earl Warren, actor Gary Cooper and his wife Rocky, and Marilyn Monroe.

Another favorite off-duty pastime was surfing. In this 1934 photo, a dejected Pete Peterson watches from the lifeguard rescue truck as lifeguards John McMahon, Bob Butt, and Wally Burton prepare to enjoy their day off by going on a surf trip.

Enjoying a break from a long day of surfing are guards Bob Butt, Wally Burton, and John McMahon. All three would become officers in the City of Santa Monica Lifeguard Service.

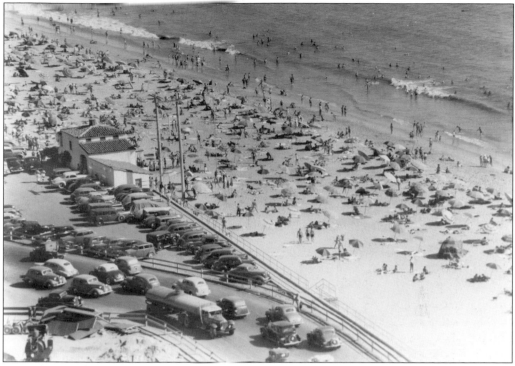

As evident in this June 9, 1937 photo, State Beach, at the base of Santa Monica Canyon, was one of the most popular beaches in Southern California.

Pictured here are members of the County Lifeguard Service who were among the first lifeguards to patrol and protect State Beach. From left to right are (front row) Sam Shargo, George McMannis, Christy Miller, Mike Safonov, Cal Porter, and Nate Shargo; (back row) Ray Porter, Hugh Wallers, and Rex Guthrie.

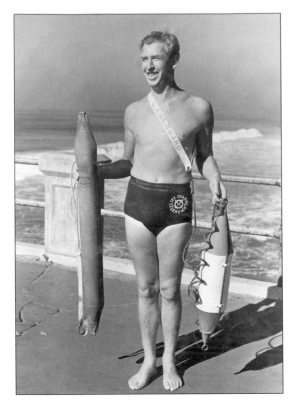

In 1941, Los Angeles County chief lifeguard Rusty Miller posed with the latest in lifeguard rescue equipment. Chief Miller would also write a popular lifesaving guide that was adopted by several lifeguard services.

In this May 1941 photo, Santa Monica lifeguards gather after completing their annual ocean recheck swim. The winner of the race happily enjoys a free breakfast courtesy of his fellow crewmates. Sadly, just months later the attack on Pearl Harbor of December 7, 1941, would forever change the lives of these lifeguards. Nearly all of them went off to serve in the war effort.

In this rare 1944 wartime photograph, Chief Rusty Miller watches as Lt. Don St. Hill explains the finer points of dory rescue work to several newly hired lifeguards. Wartime necessities forced the hiring of lifeguards as young as 16 years old.

Upon returning from service in World War II, Lt. Bill North (far right) helped run the weight pen at today's Santa Monica Casa Del Mar Hotel, which was used as a rehabilitation center for injured military personnel during the war. Bill North Jr. shows off his newly acquired muscles.

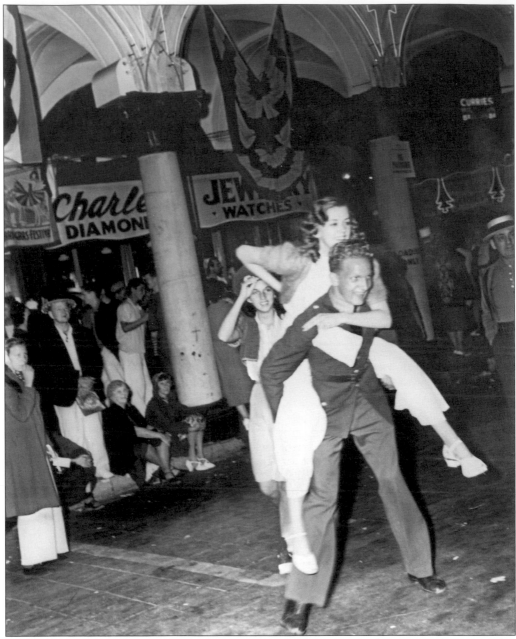

The end of the Second World War brought joy and celebration to the streets of Los Angeles, as seen in this night photograph taken just blocks from the beach in Venice.

Four

THE GOLDEN AGE OF LIFEGUARDING

1946–1964

The end of the Second World War brought forth a golden age of lifeguarding. Returning from military service, lifeguards brought back with them a strong organizational spirit that helped to further professionalize the lifeguard services for which they worked. Developments in wartime technology and lessons learned on the battlefield also helped to reshape the world of ocean lifesaving. For example, new uses for fiberglass enabled the manufacturing of swifter and more maneuverable lifeguard rescue boats, and lighter and faster rescue paddleboards. Similarly, wartime advances in the rubber industry led to the development of the rescue tube and the wetsuit.

Lifeguards veterans were also quick to encourage the incorporation of new techniques in emergency medical treatment. These updated emergency procedures came with new first aid materials and equipment that enabled lifeguards to better save lives. Also of tremendous help in saving lives of beachgoers was the introduction of the Willys four-wheel drive jeep. Introduced onto Los Angeles beaches at the war's end, the Willys allowed lifeguards to more effectively cover large stretches of beach and to quickly carry out emergency first aid and rescue operations.

Also benefiting lifeguards was the rise of international lifeguarding competitions during the 1950s, the most prominent of which was held in Australia alongside the 1956 Olympic Games. The international competitions, which continue today, not only served to keep lifeguards in top physical condition, but also to encourage sharing ocean lifesaving knowledge and technology.

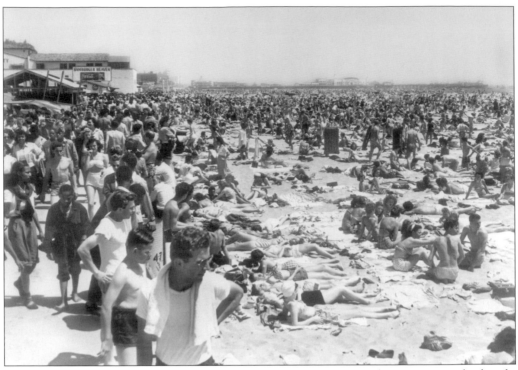

At the conclusion of the Second World War, Angelenos were quick to return to the beach. This crowd enjoyed the sun and sand at Santa Monica North Beach on Memorial Day 1946.

The south side of the Santa Monica Pier is seen here on Memorial Day in 1946.

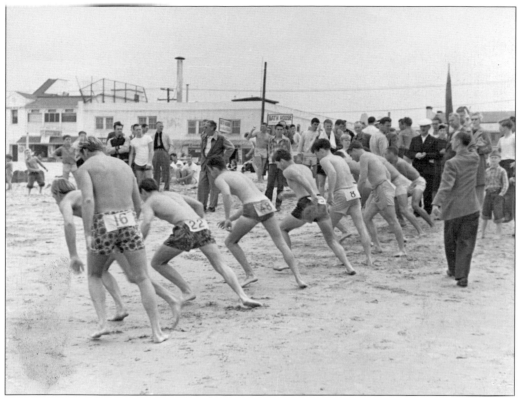

Here, a group of potential Los Angeles County lifeguards prepare for a run-swim-run exam. More than 300 qualified candidates apply for a space in the Los Angeles County Lifeguard Service each year. On average, the agency hires only the top fifty ocean swimmers in its 1,000-meter ocean swim competition.

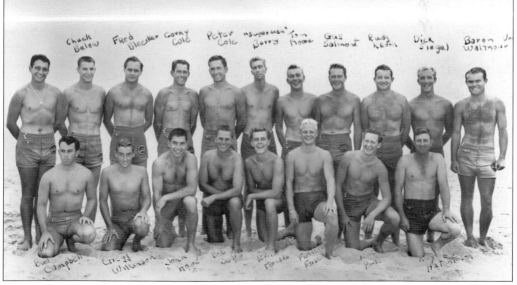

Gathered together for their summer crew photograph are members of the Santa Monica Lifeguard Service. Many lifeguards in this late 1940s photograph were returning war veterans.

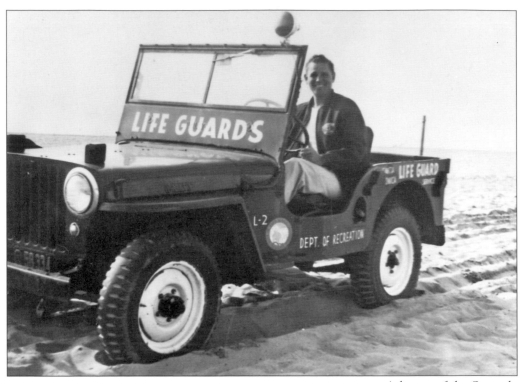

A legacy of the Second World War was the introduction of Willys four-wheel-drive jeeps as lifeguard rescue vehicles. Here, guard Bob Sears is seen driving one of Santa Monica's jeeps. The Willys were in use on Santa Monica beaches until 1974.

In this January 28, 1946 photo, a model demonstrates the sturdiness and safety of the Willys jeeps as they hit the sand with county lifeguards Ted Davis and Don St. Hill.

Pictured here are Los Angeles County lifeguards Bill and Bob Meistrell, founders and owners of the internationally renowned Body Glove Corporation. Along with fellow county guard, Bob Morgan, they would create a wetsuit revolution that enabled ocean enthusiasts to surf and scuba diving year round.

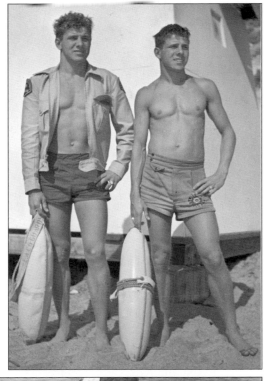

Pictured here are members of the Los Angeles County Lifeguard Underwater Recovery Team, the first such one in the nation. The team would later help police and fire departments create their own underwater recovery teams.

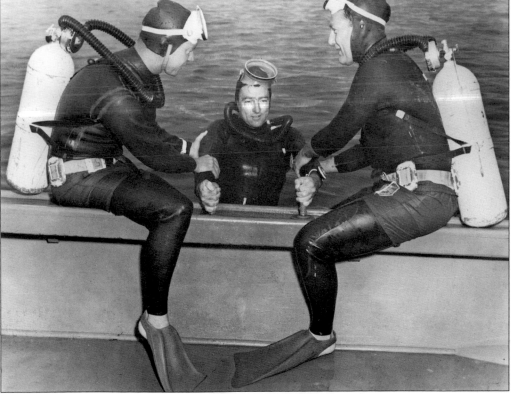

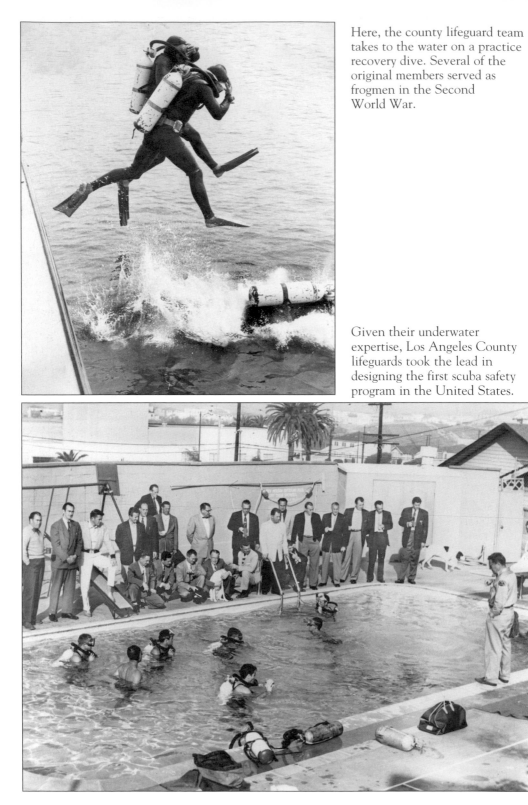

Here, the county lifeguard team takes to the water on a practice recovery dive. Several of the original members served as frogmen in the Second World War.

Given their underwater expertise, Los Angeles County lifeguards took the lead in designing the first scuba safety program in the United States.

This August 21, 1947 photograph shows the launching of the very first Los Angeles County Baywatch lifeguard boat. The name of the rescue boat was the result of a contest and the winning name, given by a woman living in Culver City, was so popular that it remains in use for all Los Angeles County lifeguard boats.

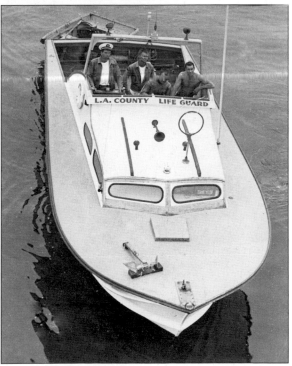

Aboard a Baywatch lifeguard boat preparing to dock are, from left to right, skipper Bill Stidham, Gordon Tyner, Frank Rodecker, and Ted Davis. Lifeguard Davis was a noted deep-sea diver.

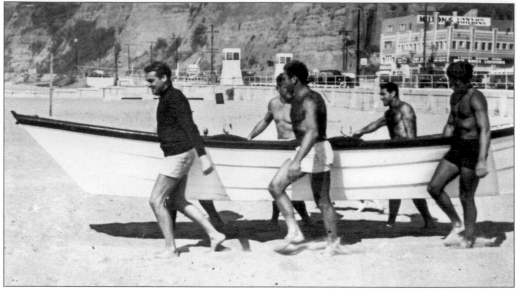

In this 1948 photograph, L.A. County lifeguards at State Beach are seen carrying their station's dory down to the water for a crew workout.

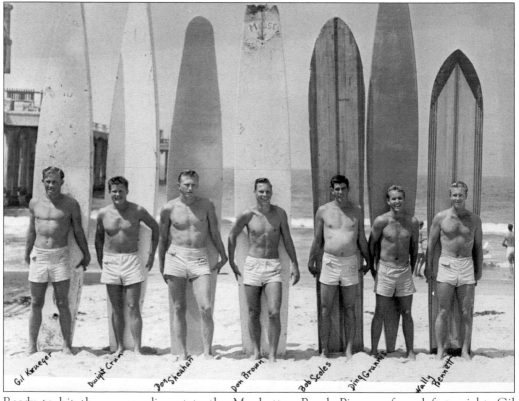

Ready to hit the waves adjacent to the Manhattan Beach Pier are, from left to right, Gil Krueger, lifeguard chief Dwight Crum, Don Sheahan, lifeguard and noted surf photographer Don Brown; lifeguard Bob Scoles, who served as a navy frogman in World War II; Ding Grannis; and fellow county lifeguard Wally Bennett.

In the years following the Second World War, junior lifeguard programs became very popular. Here, Santa Monica instructors (from left to right) Bill North, Rudy Kroon, and Frank McMahon get their proteges warmed up. Striking an early blow to open the program up to women is Susan North, proudly flexing front and center.

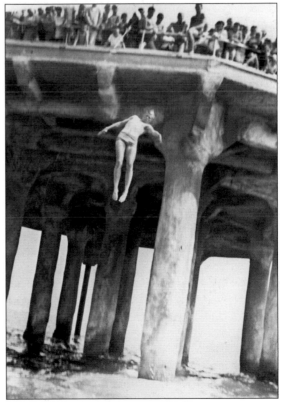

In front of a large crowd—including a determined fisherman—a county lifeguard performs a pier jump of the Manhattan Beach Pier. The pier jump is required of all ocean lifeguards.

Members of the 1947 county lifeguard emergency call crew gather together on the Hermosa Beach Pier. Pictured, from left to right, are Bill Stidham, Don St. Hill, Bob Scoles, James Bailey, Joe Potts, and Frank Rodecker.

In this 1951 photograph, lifeguard Wally Bennett demonstrates to lifeguard candidates a new post–World War II resuscitator. Despite its many advances, the resuscitator still took two lifeguards to carry it.

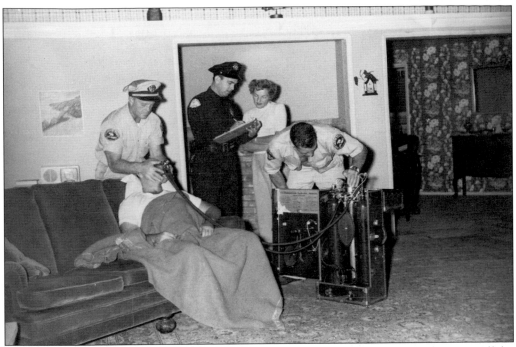

It was not uncommon for lifeguards of all three services to be called out to emergencies off the beach. Here, members of the County Lifeguard Service give oxygen to a Hermosa man who is suffering from breathing difficulties.

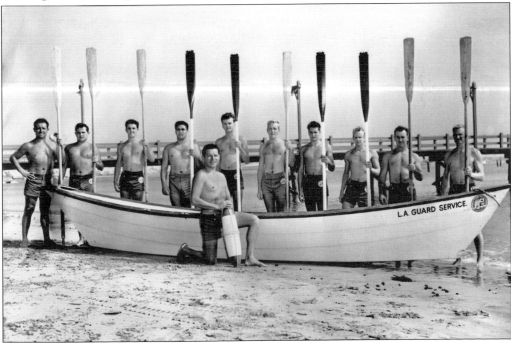

Holding a metal rescue can, lifeguard captain John Olguin poses in front of his 1951 Cabrillo Beach lifeguard crew. Awarded the Silver Star in World War II, Captain Olguin would go on to found both the Los Angeles Maritime Museum and the Cabrillo Marine Museum.

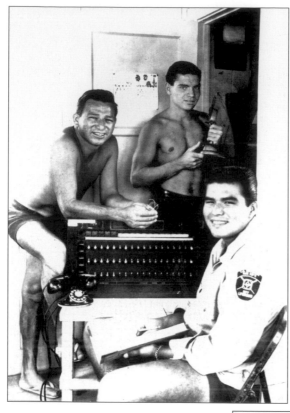

In this 1951 photo are Los Angeles City lifeguards Bob Tonjez, (seen with microphone), lifeguard captain John Olguin, who was named in 2000 as citizen of the century for the City of San Pedro; and Gilbert Sales, who became a well-known medical doctor for NASA.

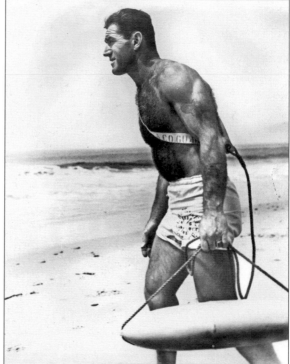

As large postwar crowds hit area beaches lifeguards had to be ready for anything and everything. Here, Nate Shargo keeps an eye on swimmers along State Beach.

County lifeguard Gordon Tyner hits the sand after spotting a swimmer in trouble.

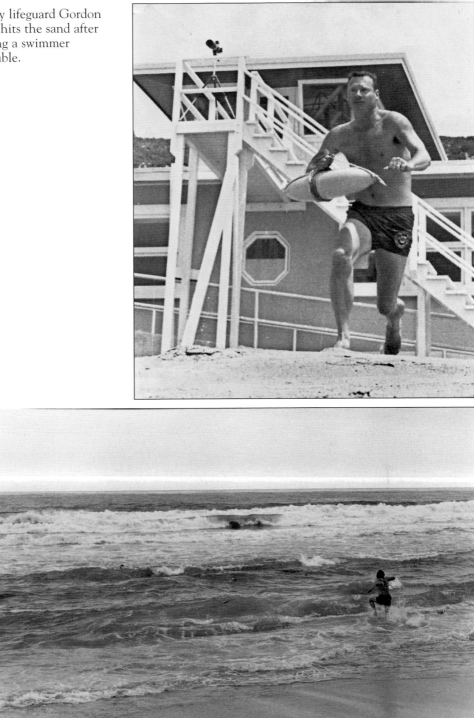

As the lifeguard hits the water, the victim's head can be seen on the left side of the photo. The struggling swimmer is trapped in an inshore hole. The victim was successfully rescued.

Lifeguard Buzzy James performs a double rescue of two swimmers trapped in an inshore hole.

"Tarzan," the mascot of the L.A. County lifeguards at State Beach in Santa Monica Canyon, stands at the ready to back up lifeguards there.

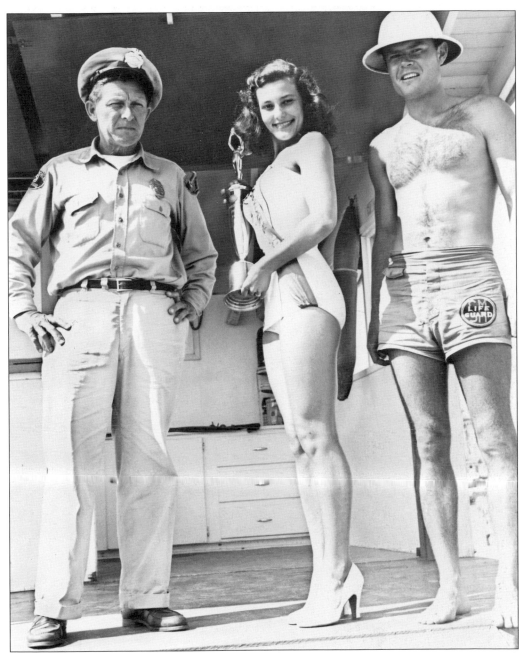

Miss Santa Monica 1952 poses with Lt. Bill North and guard Bob Walthour. Walthour would become one of the nation's leading high school swim coaches.

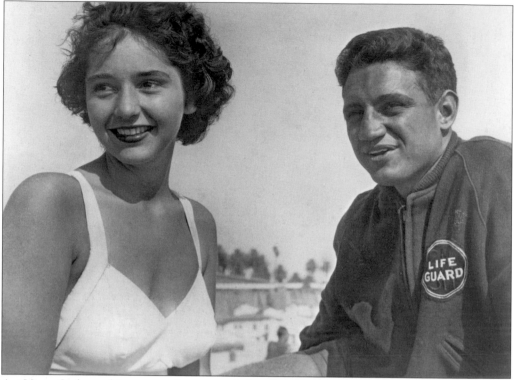

Art Verge Sr. keeps his eyes on the water while talking with a pretty Santa Monica beachgoer.

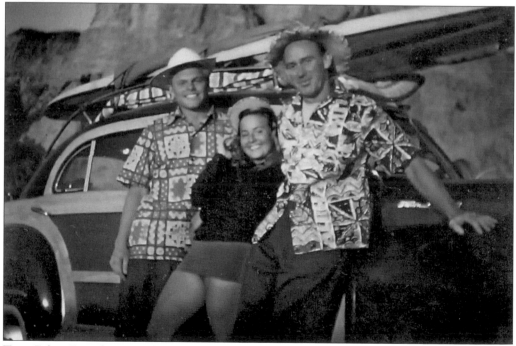

Tom Zahn, Darrylin Zanuck, and Pete Peterson enjoy a still popular lifeguard tradition—a surfing trip to San Onofre.

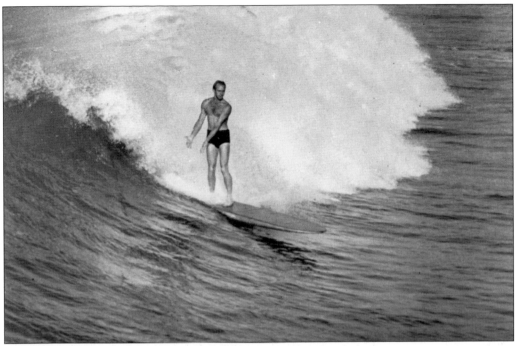

Pete Peterson enjoys riding a wave north of the Hermosa Beach Pier.

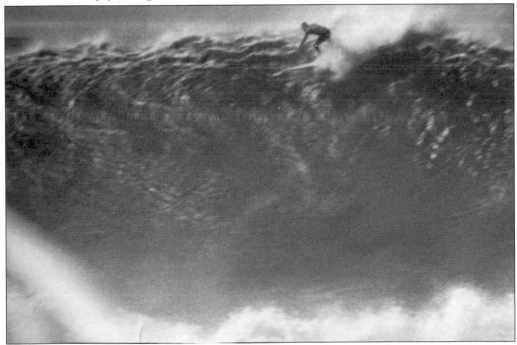

Nicknamed "The Bull" for his physical size and fearless wave riding, L.A. County lifeguard Greg Noll is considered the father of big wave riding. In this 1959 photo by fellow lifeguard Bud Browne, Noll takes on Waimea. Browne is known today as the original surfing moviemaker. Because of their impact on the sport, both Noll and Browne are members of the International Surfing Hall of Fame.

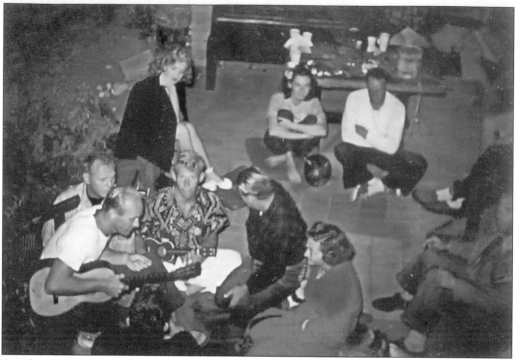

Another favorite popular pastime of off-duty lifeguards was getting together for a summer evening luau. This luau was held at "Cap" Watkins house on Malibu Beach. Tom Zahn's girlfriend at the time, Marilyn Monroe, can be seen in back.

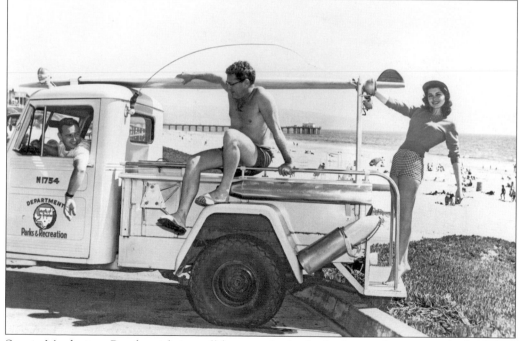

Scenic Manhattan Beach, with its well-known pier in the background, serves as the backdrop for this photo of a model aboard a 1950s lifeguard truck.

Actor Aldo Rey, left, joins county lifeguard Ted Davis aboard the South Bay's lifeguard call car as it prepares to leave from Hermosa Beach Pier.

A news photographer caught these two county lifeguards as they rushed to the scene of a man down in a nearby Hermosa Beach shopping center. Notice that the 1950s resuscitator took two lifeguards to carry it.

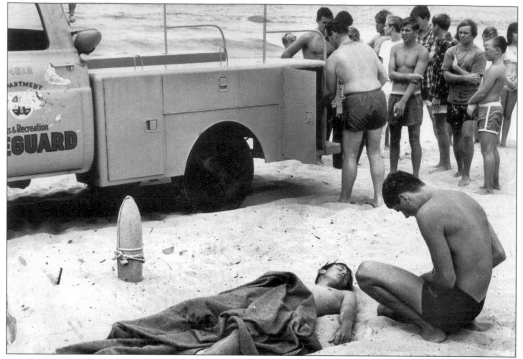

A lifeguard takes a report of a young man injured in a surfing accident. Los Angeles County lifeguards handle over 7,000 medical assists a year.

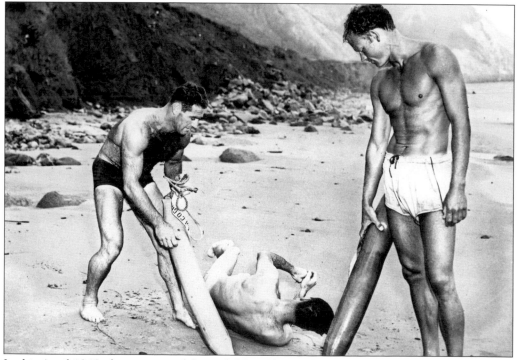

In this April 1948 photo, county lifeguards Nate Shargo, left, and Cal Porter prepare to remove the body of a man who drowned while swimming at night off the coastline of Malibu.

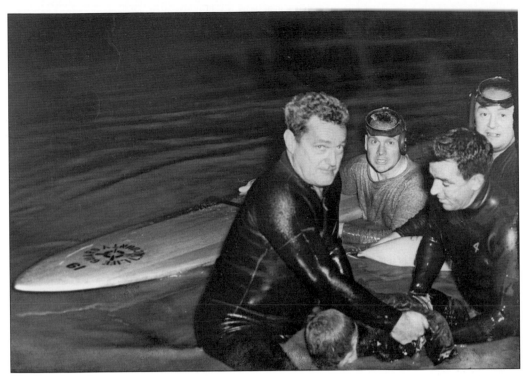

The Los Angeles County Lifeguard Underwater Recovery Team brings to shore the body of man who committed suicide on Easter evening of April 6, 1958.

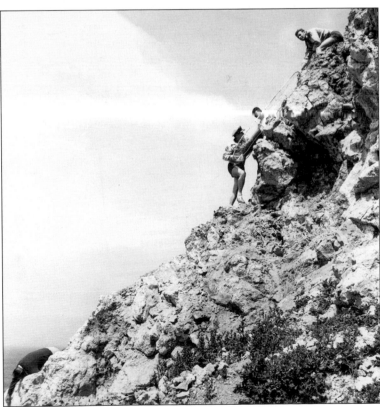

Lifeguards prepare to remove the body of a man who committed suicide by jumping off a cliff along the Rancho Palos Verde coastline.

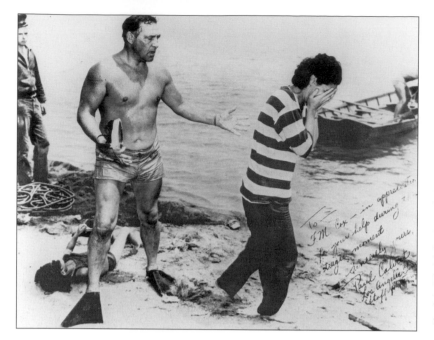

A speechless Myron Cox stands helpless as a mother suddenly realizes that her worst fear has been realized. Chief Cox of the Los Angeles City Lifeguard Service was called to Hansen Dam to assist in the rescue search operation. The heart-wrenching photograph by Paul Culvert won several national awards.

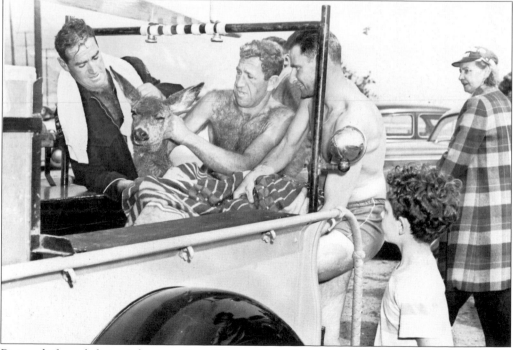

Pictured, from left to right, are Nate Shargo, Sam Shargo, and Cameron Thatcher as they prepare to return a deer to the wild after rescuing it from the ocean in March 1949. The deer was swept out to sea from a rain-swollen Topanga Creek.

As the population of Southern California grew during the postwar years, so did the Los Angeles County Lifeguard Service. Here, Nate Shargo and his brother Sam put up a first aid sign for beachgoers on the newly acquired and now lifeguard protected Zuma Beach.

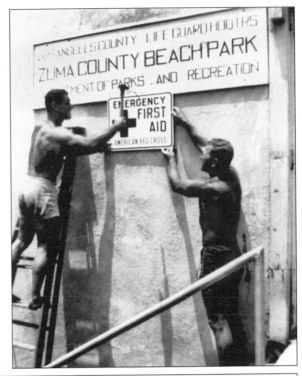

Many of the lifeguards who returned from military service in the Second World War helped to instill a greater degree of professionalism throughout the three lifeguard services. Among the changes was the incorporation of khaki dress uniforms worn by the permanent staff of the Los Angeles County Lifeguard Service. The uniforms, complete with ties, were similar to those worn by officers in the United States Navy.

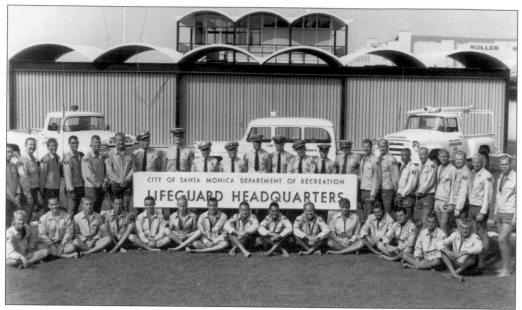

Here, members of the Santa Monica Lifeguard Service gather in front of the Central Section Lifeguard Headquarters, which is still in use today. Founded in 1932, the Santa Monica Service would merge into the Los Angeles County Lifeguard Service on July 1, 1974.

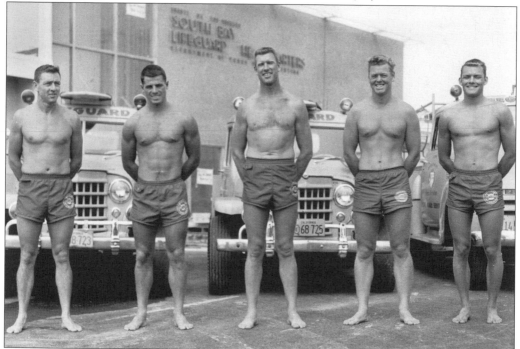

In this September 17, 1957 photo, Los Angeles County lifeguards, from left to right, Mickey O'Brien, Toby Erlinger, Paul Matthies, Bud McCamy, and Fred Tissue gather together in front of one of the first, but since torn down, South Bay Lifeguard Headquarters. Paul Matthies was the first American to win the prestigious International Lifeguard Iron Man competition. He revolutionized ocean lifeguard competitions by developing the first self-bailing dory.

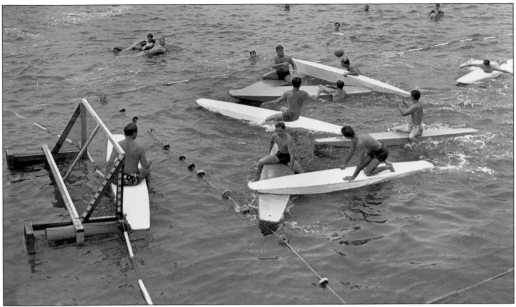

Here, Santa Monica and Los Angeles City lifeguards battle it out in game of paddleboard water polo. The games often drew large crowds who watched the competitions from bleachers on the Santa Monica Pier.

Los Angeles County lifeguard captain Don Hill shows the trophy that will be presented to the winning lifeguard team in an upcoming swim competition to be held at the Los Angeles Olympic swim stadium. Pictured in the Willys lifeguard jeep are Jessie Edgar (wife of lifeguard Bill Edgar), left, and Cathy Porter (wife of lifeguard Cal Porter).

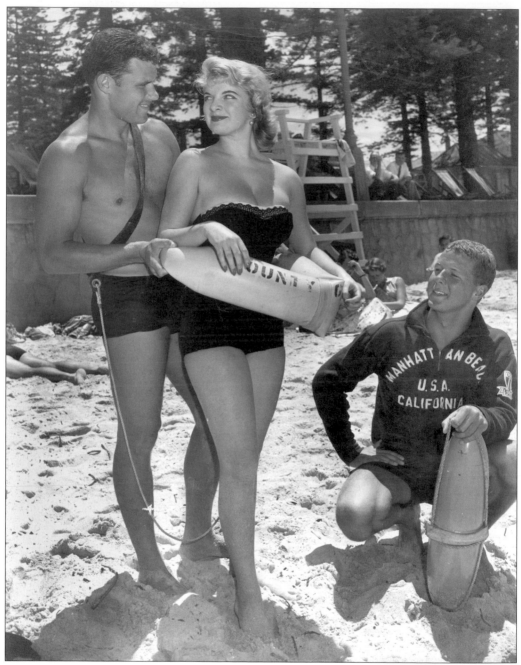

This photo, taken at the 1956 International Surf Lifesaving Games in Sydney, Australia, shows Santa Monica lifeguard Ted Devine (left) demonstrating to news photographers how to wrap on a rescue tube. Divine uses beach local Margot Day as his practice victim while L.A. County lifeguard Dave Balinger looks on. Devine, the son of L.A. City lifeguard and well-known movie actor Andy Devine, was a double gold medalist in the games.

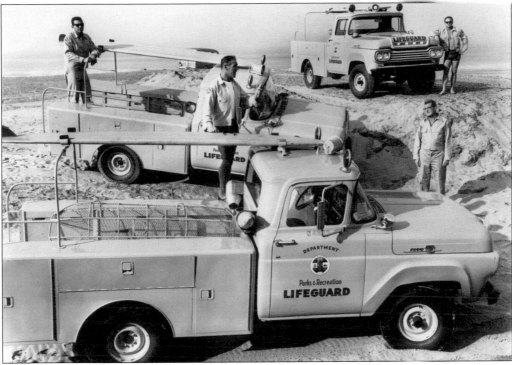

New Los Angeles County lifeguard trucks are posed together on Zuma Beach in this December 16, 1959 photograph.

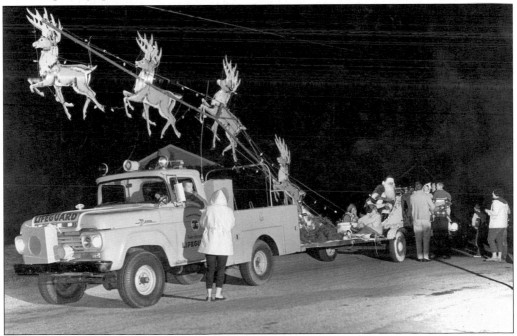

As seen in this 1950s photograph, Los Angeles County lifeguards have always been ready and willing to help Santa Claus make his way around area beaches. Santa enjoys riding on the Baywatch as he makes his way around holiday boat parades every December.

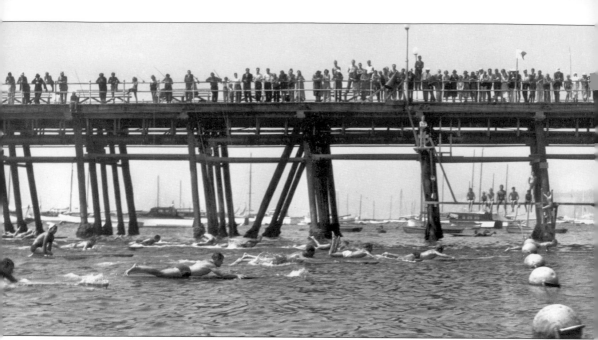

A large crowd gathers on the Manhattan Beach Pier to greet paddlers who were racing towards the finish line in a race that started from Catalina Island. Leading the pack were several lifeguards, including winner Tom Zahn.

In this early 1950s photo, Santa Monica lifeguard Bob Walthour enjoys the company of several beauty contest winners. The photo was later used in the end credits of *Baywatch*.

Five

BEACH BLANKET
BABY BOOMERS
1965–1988

By 1965, nearly every youngster living along the Southern California coastline was talking about the world of surfing and surf culture. From the music of The Beach Boys, to surfboards strapped atop of cars, to the sprouting of local surf shops, surfing and its attendant "culture" was becoming a fixture throughout the region's beach communities. Helping to foster its attraction were lifeguards, many of whom taught the sport to interested youngsters.

As interest in the sport grew with popular movies and music as well as nationally distributed surf magazines, so did the reputation of the L.A. Lifeguard Services, who had in their employ many of the world's top surfers. Among them were world titlists Mike Doyle and Ricki Gregg, as well as legendary big wave rider Greg Noll.

Throughout the 1960s, much like the rapidly growing beach cities behind them, lifeguards saw in front of their station windows dramatic increases in activity as surfers, swimmers, and Coppertone covered sun seekers all competed for their place in the sun. By 1973, the three-lifeguard services saw their crews and budgets being stretched to the breaking point. Arguing that having three separate lifeguard organizations was in effect an unnecessary duplication of services, civic leaders merged both the Santa Monica and Los Angeles City Lifeguard Services into the county lifeguard service. On July 1, 1975, the consolidations were complete thereby making the Los Angeles County Lifeguard Service the largest ocean lifeguarding organization in the world.

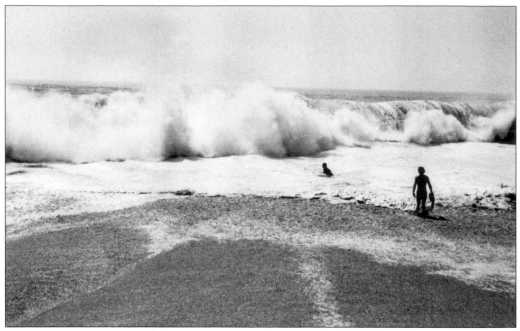

This 1972 Venice Beach photo shows a Los Angeles City lifeguard standing at the ready as a wayward bather wisely returns to the shore. The Los Angeles City Lifeguard Service would merge into the Los Angeles County Lifeguard Service on July 1, 1975—exactly one year after the Santa Monica merger.

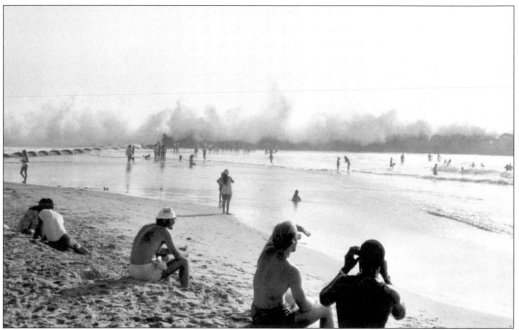

Beachgoers watch in amazement as large surf swells over the Venice Breakwater. The Venice Breakwater and the avenue beach areas to its south remain a very high activity area for Los Angeles County Lifeguards. In 1999, lifeguards made over 2,000 rescues on the beaches of Venice alone.

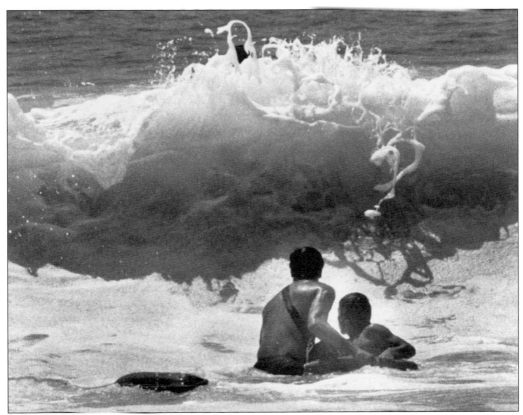

A lifeguard steadies a rescued boogie-boarder. Boogie boards, which came onto the scene in the mid-1970s, have proved to be a mixed blessing for lifeguards. Boogie-boarders often go out in areas beyond their swimming capabilities. At the same time, though, boogie boards can serve as a flotation device for those in trouble.

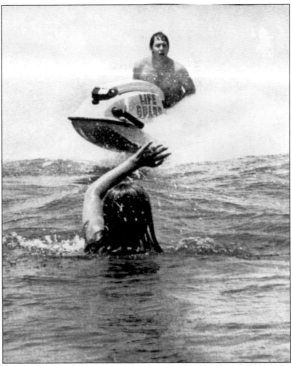

Beginning in the 1970s, among the new rescue equipment employed by L.A. County lifeguards was the personal watercraft known as the Jet Ski. In this 1977 photograph, lifeguard Don Dewald demonstrates how lifeguards use it to make ocean rescues.

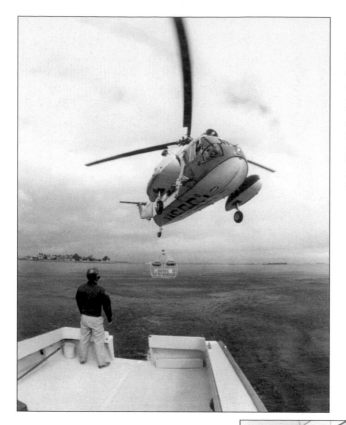

In this 1980s photo, guard Rich Bates awaits the arrival of a U.S. Coast Guard helicopter. Both services continue to work very closely with one another to provide ocean rescue protection. The Los Angeles County Lifeguard Service is the only lifeguard agency in the United States to have one of its lifeguard rescue boats stationed at a U.S. Coast Guard naval base.

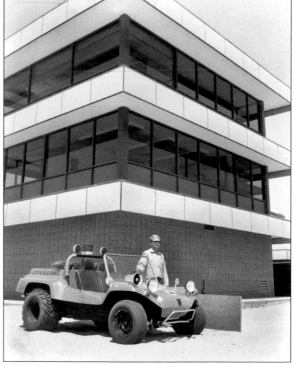

Capt. Jerry Shoemaker stands next to a 1970s dune buggy. Unfortunately, the experiment to use dune buggies failed in large part due to beach sand that would clog the machine's carburetors.

Longtime Los Angeles County boat skipper Capt. Bud McKinely skillfully works on making a replica of Baywatch II. As part of his wood components, McKinely used wooden tongue depressors, coffee stirrers, and toothpicks to help create a perfect scale model.

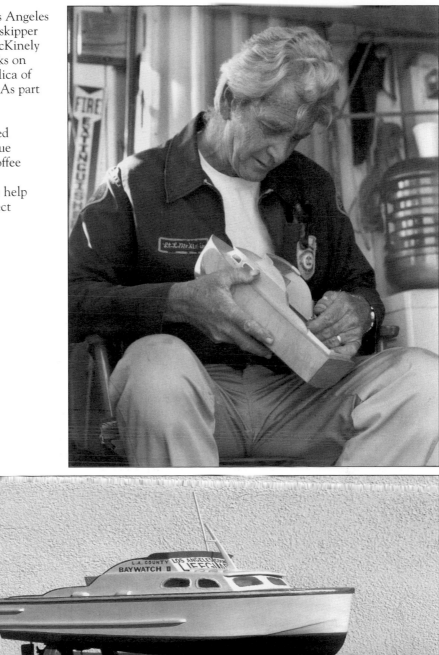

In creating the Baywatch II model, Skipper McKinley used original Baywatch paint. The boat was inlayed with teak and mahogany, and the pilot's wheel alone was made with 32 pieces of wood.

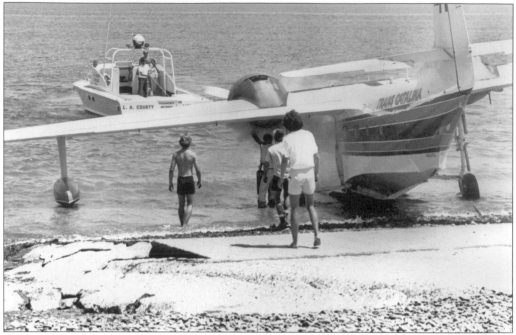

On April 14, 1979, a Catalina seaplane crashed off Avalon. Los Angeles County lifeguards safely evacuated and rendered medical assistance to the plane's surviving passengers. Here, Baywatch Avalon can be seen moving the downed plane.

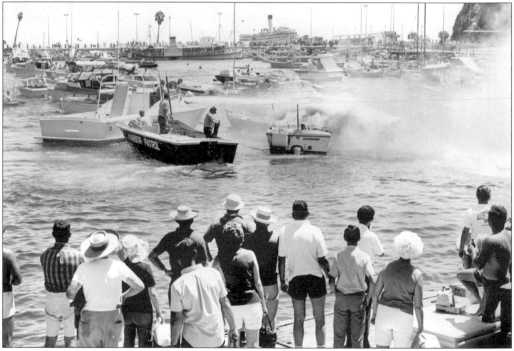

In this August 9, 1970 photo, Los Angeles County lifeguards can be seen aboard a Baywatch rescue boat fighting a nearby boat fire in Avalon Harbor. Note the old Catalina steamer in the far background.

94

Operating the hyperbaric chamber on Catalina Island in 1975 are lifeguards John Stonier and Roger Smith. The chamber remains in use today with lifeguard paramedics often being called on to treat a range of hyperbaric injuries suffered by scuba divers and aviation pilots.

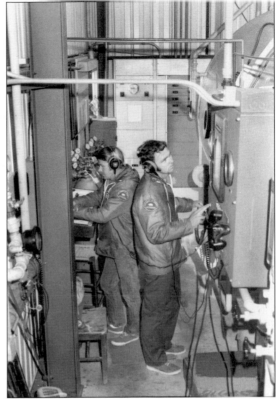

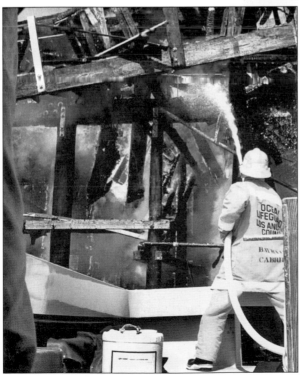

Lifeguard Scott Moore is seen fighting the Redondo Beach Pier fire of May 27, 1988, from the Baywatch Cabrillo.

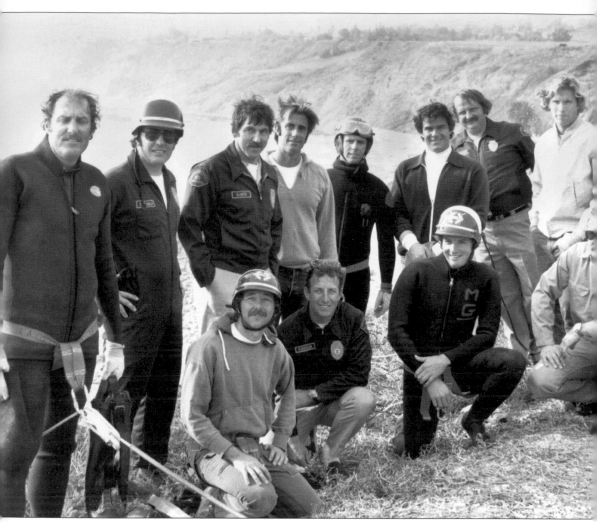

Members of the 1979 Los Angeles County Lifeguard Dive Team gather after a training drill. They are, from left to right, (front row) Ira Gruber, Shelly Butler, Mickey Gallagher, and Dan Cromp; (back row) Steve Gregg, Don Dewald, Dave Heck, Steve Litscher, Tom Estlow, Brian Turnbull, Joe Reinisch, and Tim Hooper.

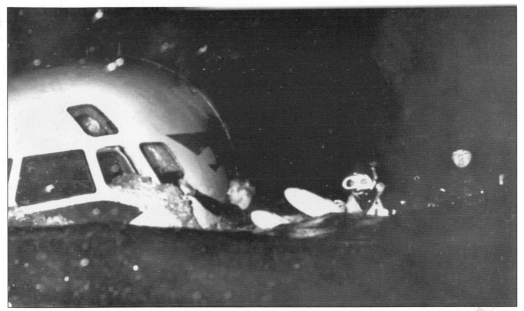

L.A. County lifeguards Jeep Shaeffer, John Stonier, and Bill Nisbet prepare to enter a downed Scandinavian Airlines DC-8 that crashed during a powerful rainstorm while on approach to LAX. Lifeguard Shaeffer, who was also a TWA pilot, led the lifeguard rescue team into the plane during the January 13, 1969 disaster. Due to their timely response, lifeguards were credited with saving the lives of 30 of the 45 passengers.

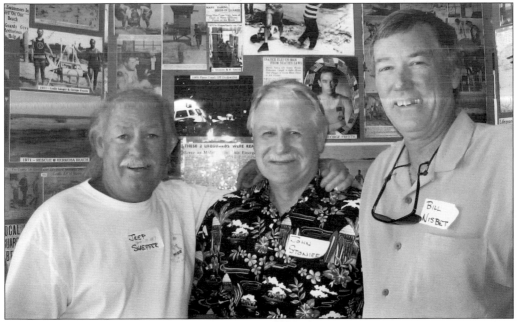

Reunited at the lifeguard alumni party in June 2004, lifeguards Shaeffer, Stonier, and Nisbet, pose together in front of the well-known SAS airliner photograph. In one of the strange twists of history, another airliner would go down five nights later near the site of the original SAS crash. Sadly, despite another speedy response from lifeguards, all 38 passengers of the downed United Airlines Boeing 727 died on impact.

Sharon Law, Los Angeles County's first permanent female lifeguard, keeps watch over bathers down the beach from the Hermosa Pier. The powerful binoculars seen in this 1985 photo are still in use today. At the conclusion of the Second World War, the binoculars were taken off a German warship.

In this February 20, 1946 photograph, lifeguard Dick Scoles, who served in the Second World War as a U.S. Navy Underwater Demolition Team frogman, is seen using the South Bay Headquarters binoculars.

Although a "Lot Full" sign is a common sight on busy summer weekends today, the $1.25 price to park all day is not. This May 29, 1978 photo was taken at the parking lot behind today's Santa Monica Tower No. 22.

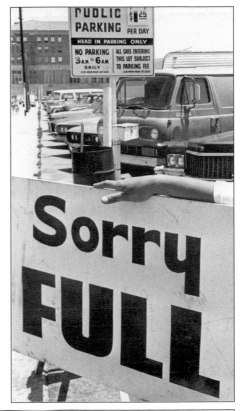

In this "the times they are a changing" 1960s photograph, lifeguard Steve Voorhees finds himself being followed by a bevy of pretty beachgoers.

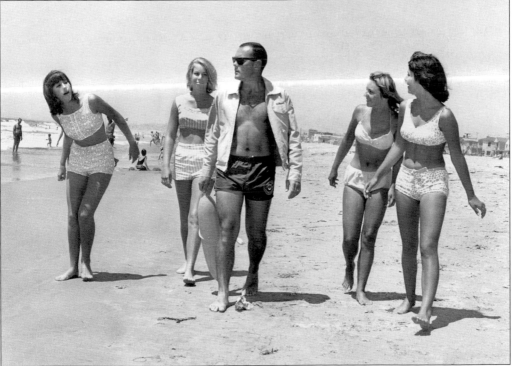

In 1979, lifeguards (from left to right) Maggie Van Oppen, Kim Peters, Theresa Van Oppen, and Kiff Kimber posed for a publicity photo for the television show *Real People*, which showed what it was like to be a female Los Angeles County beach lifeguard—including the problems encountered with overenthusiastic male patrons who wanted to follow them around while they did their job.

Shown in this 1985 photograph are many of the legends of the Los Angeles lifeguard services, including Santa Monica College swim coach John Joseph (second from left). During his 42 years of coaching, Joseph was responsible for putting more than 300 ocean lifeguards, including today's present Los Angeles County lifeguard chief Mike Frazer, on the beach.

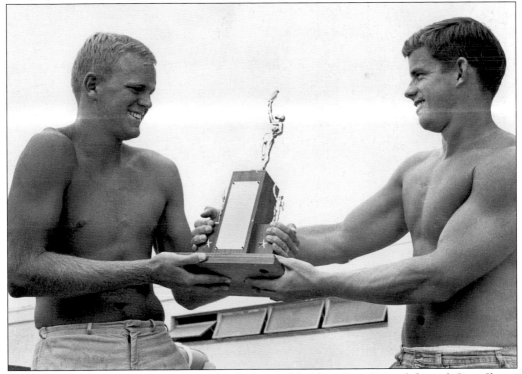

The 1964 Olympic gold medalists and world record holders, Roy Saari, left, and Gary Ilman wrestle over which of the two L.A. County lifeguard teams will win an upcoming lifeguard race.

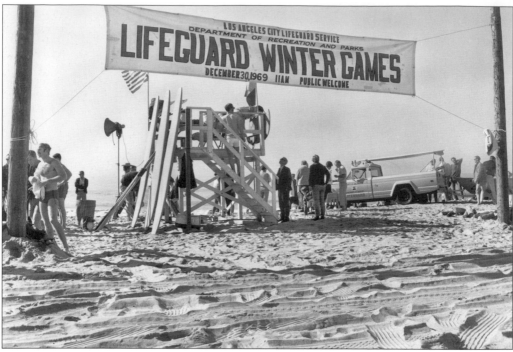

The Lifeguard Winter Games competition, shown here in the late 1960s, emphasized the need to be in top physical shape year round.

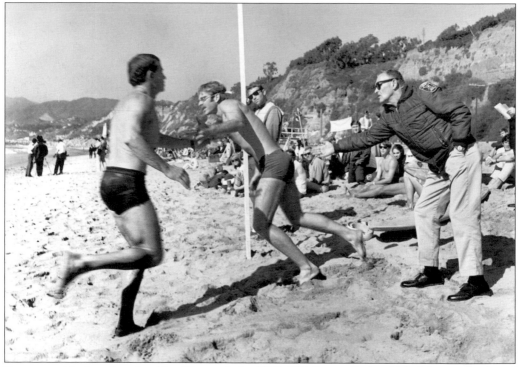

Encouraged by Los Angeles City lifeguard chief Bill O'Sullivan, Richard Mark begins his leg of the ocean relay swim in the 56 degree ocean. Mark remains a seasonal ocean lifeguard.

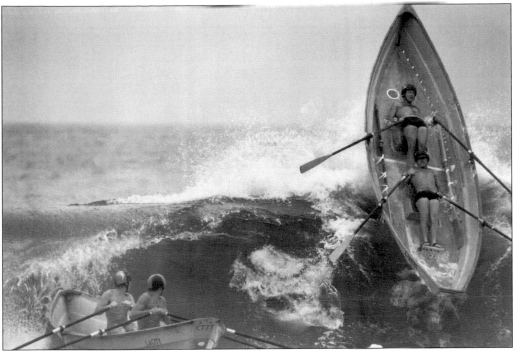

Harking back to tradition, lifeguards continue to use rescue dories to keep in shape. Dory racing is the most popular spectator sport in lifeguard competition. Atop the wave are L.A. County lifeguard captain Jake Jacobson (bow) and ocean lifeguard Dale Hast (stern).

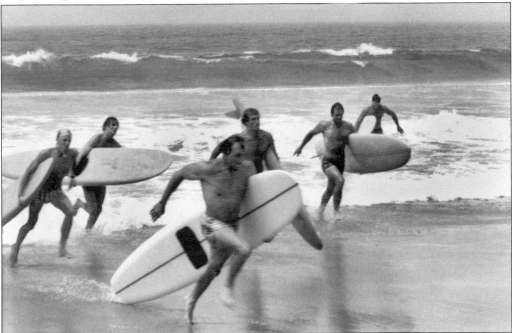

In this early 1970s photo, Mike Stevenson leads the pack as fellow lifeguard competitors exit the ocean after a hard-fought, 1,000-meter paddleboard race. A highly regarded lifeguard and ocean competitor, Stevenson was the son of former L.A. County chief lifeguard Bud Stevenson.

One of the joys of lifeguard competition is the winning of "hardware." Here, L.A. County lifeguard Andre Todd receives his award from Los Angeles county supervisor Yvonne Burke.

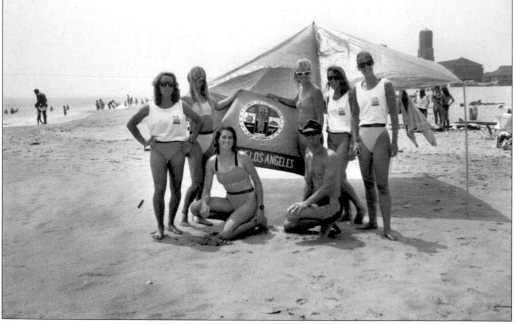

Shown here are members of the Los Angeles County Lifeguard Women's National Team. Pictured, from left to right, are (front row) Maggie Wilson and team captain Phil Topar; (back row) Kris Gipson, Shari Latta, Diane Graner, Lisa Dial, and Becky Snell.

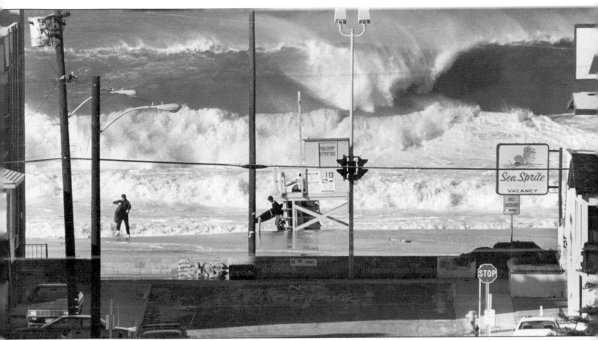

Lifeguards keep in shape to deal with ocean conditions like the scene in this January 19, 1988 photo by award-winning photographer Bruce Hazelton of the *Daily Breeze* newspaper. (Courtesy of the *Daily Breeze*.)

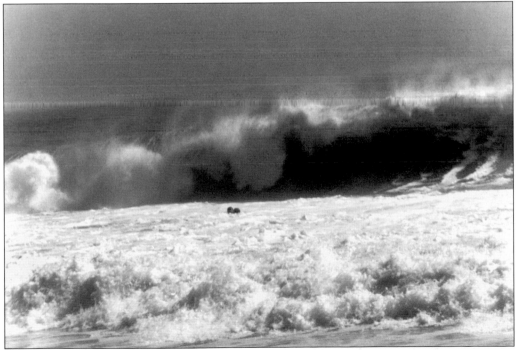

At Zuma Beach, an L.A. County lifeguard (on the left) tightly holds a drowning victim to his rescue can as they await the approach of another large wave. Despite the difficult conditions, the victim was quickly and safely returned to shore. This photo was taken on August 28, 1985.

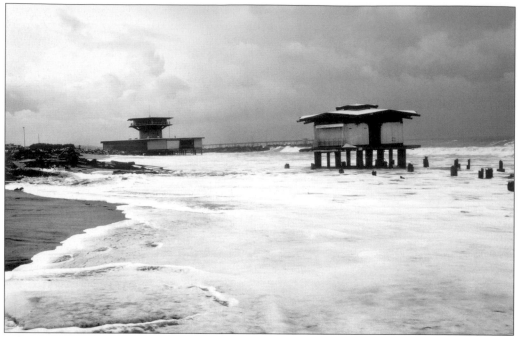

Lifeguard captain Conrad Liberty shot this photo of the restrooms located in the Avenue area of Venice Beach during the El Nino storms of 1983. Also damaged by the surge in storm surf was the Los Angeles County Lifeguard Division building which can be seen in the background.

In this February 1983 photo, lifeguard Hans Kruip captured the damage caused to the Zuma lifeguard headquarters and the surrounding beach parking lot.

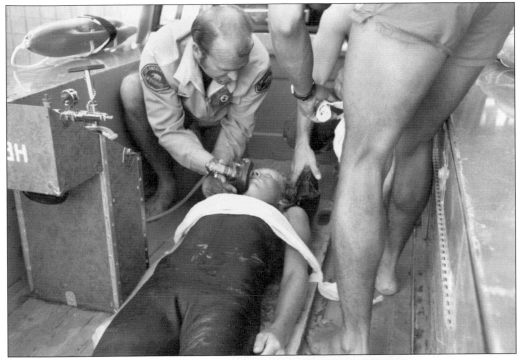

All permanent lifeguard personnel for the Los Angeles County Lifeguard Service are certified emergency medical technicians. Here, Capt. Sonny Vardeman aids an injured beachgoer. In 2004, Captain Vardeman was elected into the Hermosa Beach Surfing Hall of Fame.

While keeping an eye on the beach and aiding a beachgoer with a cut foot, lifeguard Hal Dunnigan makes a call for backup. Dunnigan is a lifeguard legend. The former navy seal has not only worked for all three Los Angeles lifeguard services, but continues to serve as a county lifeguard with over 50 years of service on the beach.

Lifeguard Danny Katayama keeps a close watch over bathers at Redondo Beach's Ainsworth Court. Katayama was a star water-polo player at UC Santa Barbara in the late 1970s.

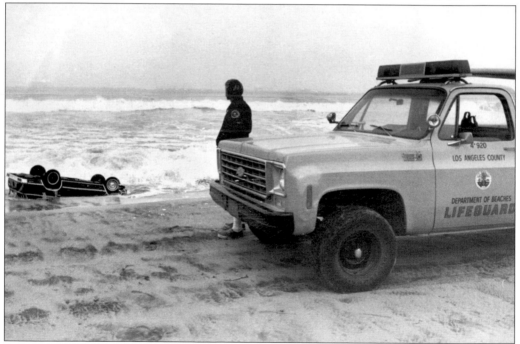

A guard looks on with disbelief as a disabled car is washed over by a high tide. Drivers sometimes believe that they can drive on beaches at night often resulting in their arrest and the loss of their car to the sea.

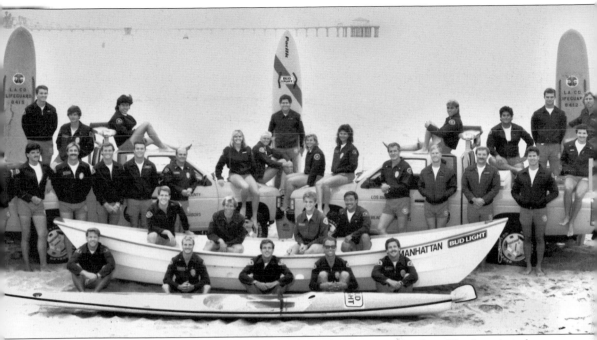

Here, members of the 1987 Manhattan Beach lifeguard crew pose together. The Los Angeles County Lifeguard Service remains the world's largest with over 800 lifeguard personnel.

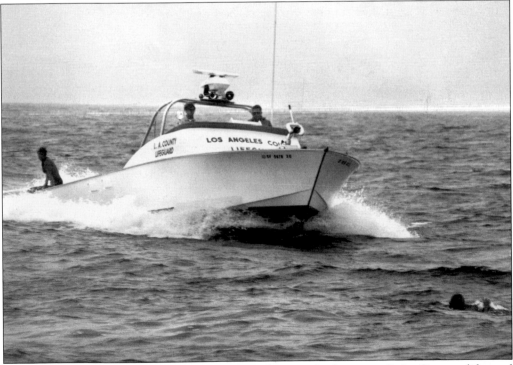

Taken by another approaching boater, this photograph shows an L.A. County lifeguard deckhand preparing to rescue a drowning swimmer. The lifeguard's rescue-can strap is around his neck as he readies himself to jump from the Baywatch.

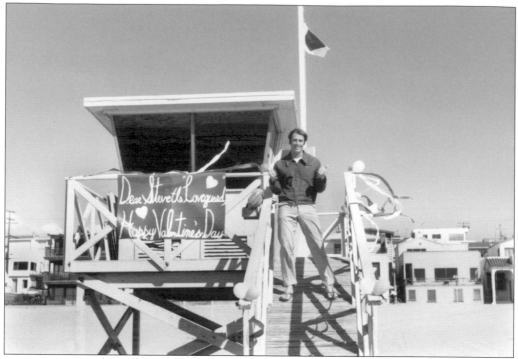

One of the benefits of working a tower year-round is having the locals and other daily beachgoers get to know the lifeguards. On February 14, 1979, lifeguard Steve Litscher arrived to find his Neptune station "lovingly" decorated by his Valentine admirers.

Capt. Mark Lozano takes in the picturesque ending of a fall day. It is the goal of every lifeguard to make sure that everyone who comes to the beach goes home safely.

Six

"Baywatched"
by the World
1989–2004

It was the show seen around the world. The brainchild of lifeguard Greg Bonann, who would become the show's executive producer, *Baywatch* put the Los Angeles County Lifeguard Service on the map. First shown in 1989, the program would rise to become the most popular television show in history.

What many viewers did not know was that the show's fictional characters were based on the lives and experiences of real Los Angeles County lifeguards. Filmed on L.A. County beaches, the program used the lifeguard service's towers and Baywatch rescue boats. It also modeled its vehicles, uniforms, and rescue equipment to those used by county lifeguards.

Baywatch proved to be a great blessing for the Los Angeles County Lifeguard Service. Seen weekly by millions of viewers in 145 countries, the program generated positive feelings towards lifeguards and the work they do. The show's high public profile proved to be effective in helping the lifeguard service maintain adequate funding as a public safety institution. That political support also helped to enable the lifeguard service to merge into the Los Angeles County Fire Department in 1995.

Presently staffed by a full-time crew of 132 lifeguards, who are supported by 650 part-time guards, the Los Angeles County Lifeguard Service remains a 24-hour-a-day, year-round operation whose mission remains focused on the vigilant protection of the lives and safety of the beach going public.

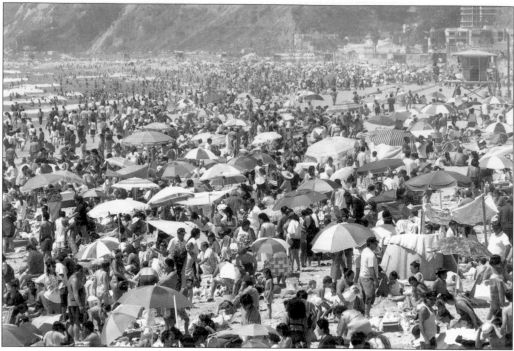

A large summer afternoon crowd gathers just north of the Santa Monica Pier. It is not unusual for beaches like Santa Monica to have weekend crowds in excess of 200,000 patrons during the peak months of July and August.

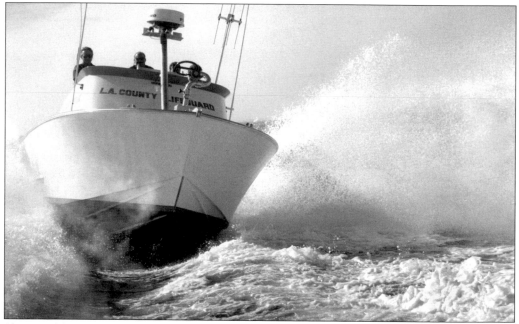

Skippered by John McKay (left) the newly launched Baywatch 16 undergoes sea trials off the coast of Santa Monica. Chief lifeguard Don Rohrer (second from the left) was instrumental in making the Baywatch boats among the most modern and best-equipped lifeguard rescue fleet in the world.

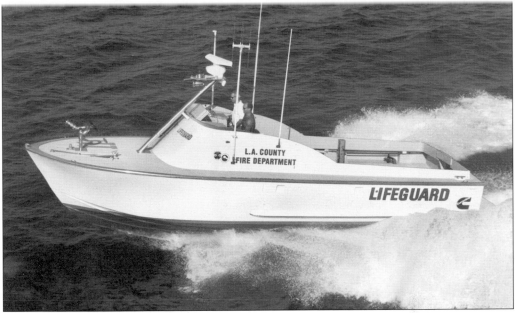

Here, Baywatch 11 is seen responding to a call. At the top is skipper Paul Pifer with deckhand Phil Navarro. Every Baywatch boat is equipped with the latest in radar, GPS, and communication gear, allowing the fleet to respond to all air and sea disasters.

Baywatch became the most popular show in television history. The show's personable star, David Hasselhoff, went out of his way to meet lifeguards who visited him on the busy set. Hasseloff was well-known for his work and support of numerous charitable events, particularly those that aided children affected with life threatening diseases. Pictured here is Hasselhoff on the set with his biggest fan, Margaret Verge.

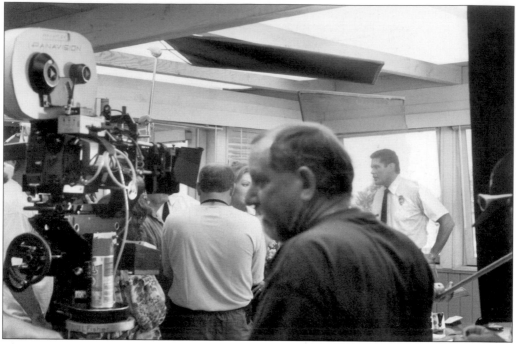

The *Baywatch* set was constructed adjacent to the real working county lifeguard headquarters at Will Rogers State Beach. Here, the production crew prepares to shoot a scene whose office overlooks the nearby beach.

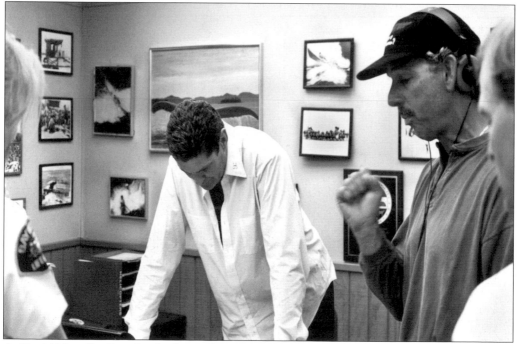

As David Hasselhoff studies his lines, director Greg Bonann gives instructions to the rest of the crew. Bonann, who remains a Los Angeles County lifeguard, was instrumental in creating and developing the hit television show.

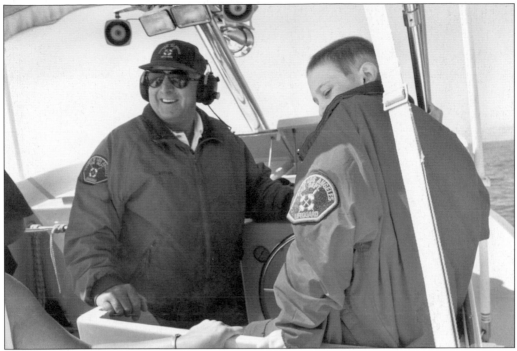

Skipper Shelly Butler watches as a U.S. Coast Guard helicopter approaches the aft section of his Baywatch rescue boat. On the right is David Wickiser, who is enjoying his visit aboard the Baywatch as part of the Make-A-Wish Foundation program.

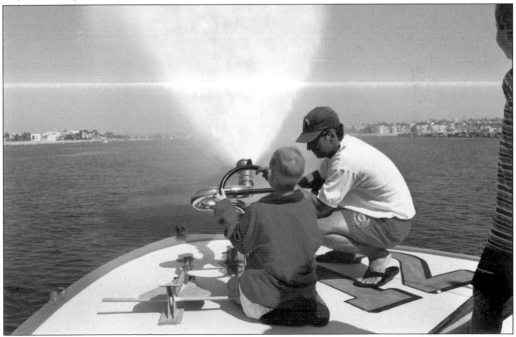

With the assistance of deckhand Simon Snyder, David Wickiser demonstrates how lifeguards fight boat and pier fires. At the end of his visit, Capt. Shelly Butler presented him with his own lifeguard captain's jacket, a present his family reports he treasures to this day.

The Los Angeles County Lifeguard Service has been the subject of two documentaries and numerous television shows. Here, lifeguards that were profiled in Turner Broadcasting's 1997 hour-long program L.A. Lifeguards pose together.

Lifeguard captain Chris Linkletter prepares to make a rescue off the waters of Manhattan Beach. The Los Angeles County Lifeguard Service has more than 60 female ocean lifeguards, including 4 female captains and 7 full-time senior ocean lifeguards.

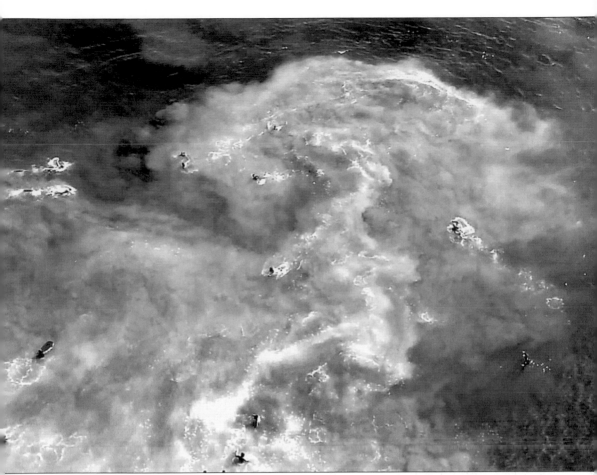

The power of deadly rip currents are seen in this photo shot from a Los Angeles County sheriff's helicopter by lifeguard captain Nick Steers on Labor Day 2004. In the top left are two county lifeguards racing to the aid of the swimmers trapped in the waters off Zuma Beach.

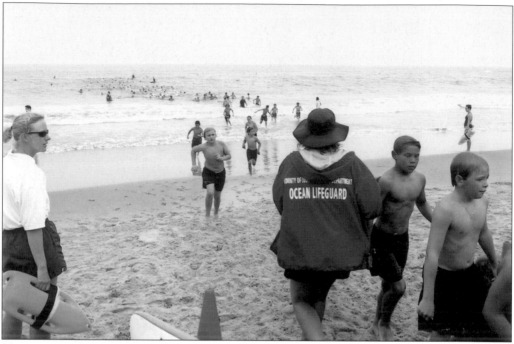

The Los Angeles County Junior Lifeguard program has over 2,000 participants every year and is responsible for helping to "drown proof" young swimmers. The same junior guards also help to promote water safety and protection to the general public. Here, a large group of junior guards successfully completes an arduous run-swim-run competition.

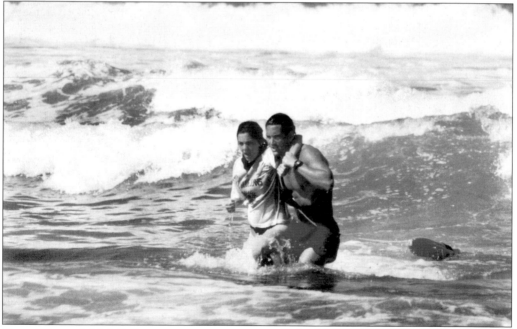

Here, lifeguard Mel Solberg rescues a swimmer off the El Porto. Solberg doubles as a Los Angeles County firefighter. L.A. County lifeguards average more than 10,000 ocean rescues a year.

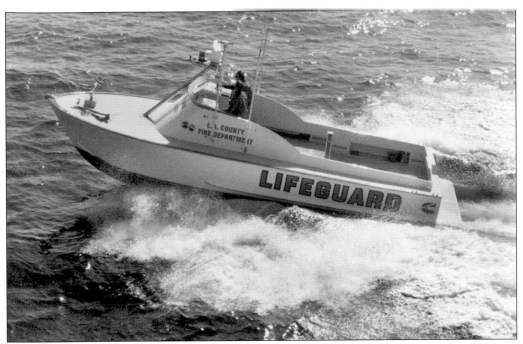

Skipper Larry Dickson and deckhand Lee Davis are seen aboard Baywatch 12, one of the 10 Baywatch rescue boats presently in service. Among the many emergencies lifeguard rescue boat crews respond to are boat fires, sinking, groundings, and offshore medical emergencies, such as diving accidents and downed aircraft.

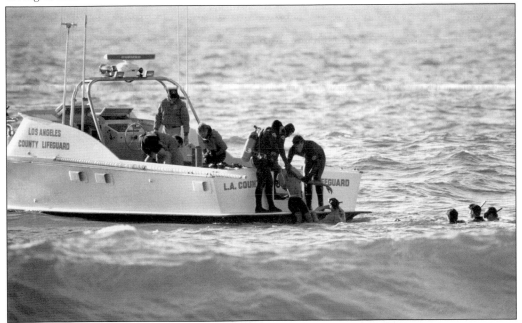

Los Angeles County Lifeguard Dive Team members can be seeing lifting a recovered body aboard Baywatch 10. The victim died as the result of a late night swim. Most drownings occur after hours. With over 50 million visitors, Los Angeles County lifeguards average less than three drownings a year. Those who do drown often have either alcohol or drugs in their systems.

Part of the Lifeguard Training Academy involves instructing lifeguard cadets how to perform difficult pier rescues. Here, a cadet jumps from the Hermosa Beach Pier as part of that training.

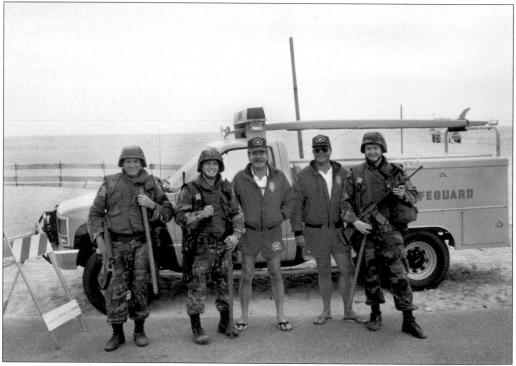

Making the best of a difficult situation are three national guardsmen and lifeguard captains Greg Allen and Dave Story. Many southland beaches were closed and off-limits during the tensions of the 1992 Los Angeles riots.

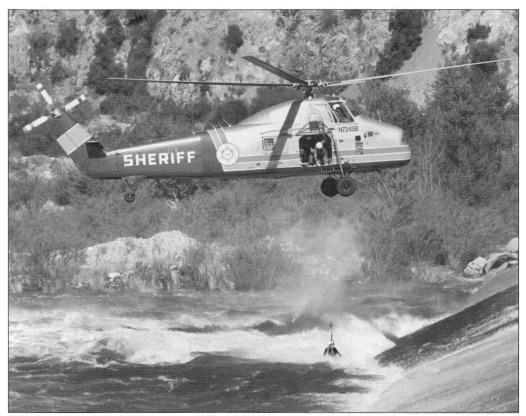

Los Angeles County lifeguards were instrumental in working with Ms. Nancy Riggs to start today's modern swift water training program. Here, a county lifeguard is hoisted back aboard a Los Angeles County sheriff's helicopter as part of a training exercise.

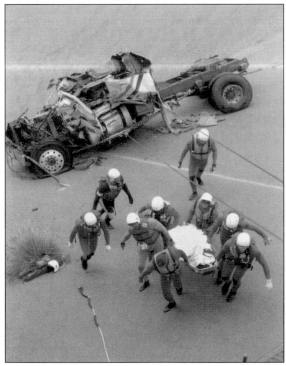

In this 1992 photo, Los Angeles County firefighters and lifeguards work together to remove the body of a truck driver whose vehicle crashed down into a rain swollen storm drain.

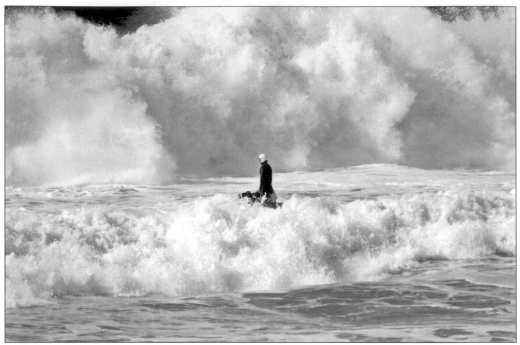

Used by both lifeguard swift water teams and ocean lifeguards on the beach are the service's seven high-speed personal watercraft. Here, lifeguard Tom Seth waits for a lull as he trains in 8-10 foot surf at El Porto in Manhattan Beach.

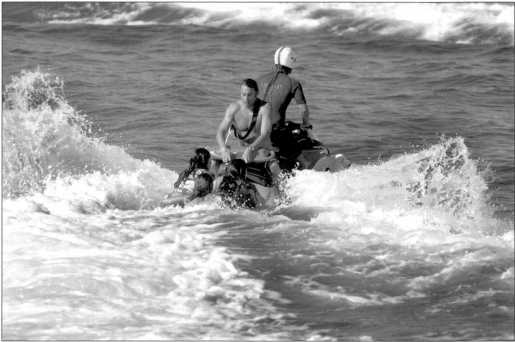

Working from the Baywatch on July 19, 2004, lifeguard Phil Navarro photographed guards Terry Harvey (PWC operator) and Steve Sturdiavant (aft) as they returned three rescued swimmers back to Manhattan Beach.

Lifeguards Jim Makuta, left, and Arthur Verge, right, finish sharing dinner and conversation with Hawaiian surfing legend Rabbit Kekai. The protege of Duke Khanamoku, Rabbit won several world titles and is considered, in the words of one writer, to be "the last living link to surfing's entire modern history." Dinners with Rabbit, who began surfing in the 1920s, bring out the shared history and deep friendships between mainland lifeguards and the people of Hawaii.

John Tabor, Los Angeles County's first African-American lifeguard, shares his experiences at assembled gathering of lifeguards and members of the Venice Historical Society on August 21, 2000. A lifeguard from 1938–1946, Tabor, who attended USC medical school, went on to become the first African-American chemist in the American aerospace industry. He remains a close advisor to the L.A. County Lifeguard History Project.

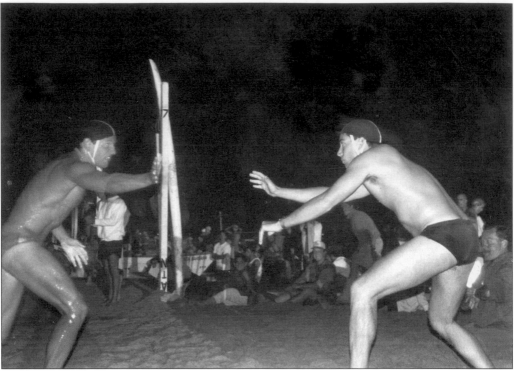

The Los Angeles County Lifeguard Service continues its focus on keeping their crews in top physical condition by encouraging lifeguards to participate in a wide range of lifeguard competitions. In this nighttime competition, Matt Mitchell, left, is preparing to tag Tim Hennessey as part of ocean swim relay. Both were national champions in the United States Lifesaving Association competitions.

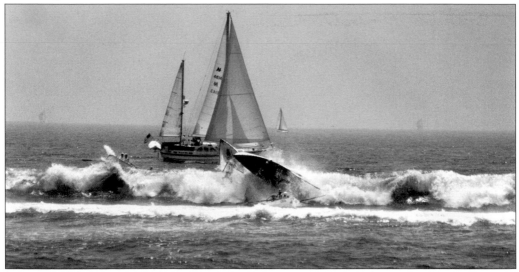

Lifeguard and national team member Joel Gitelson captured this photo of a dory crash at the United States Lifesaving Association nationals in Florida. Despite such mishaps, lifeguard competitions serve to build friendships and camaraderie between ocean lifeguard agencies throughout the country.

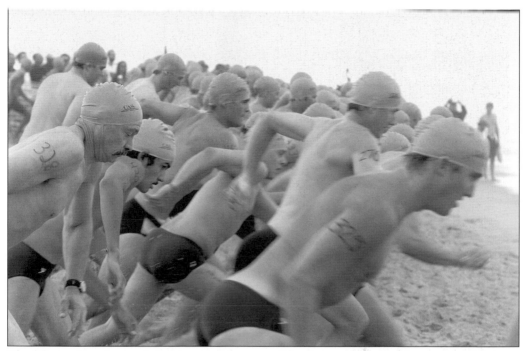

The lifeguard service works hard to recruit many of the best swimmers in the country to be part of the Los Angeles County Lifeguard Service. On average, more than 300 apply to become part of the 50 cadets selected to participate in the agency's rigorous training academy. Here, competitors begin the selection process with a 1,000-meter ocean swim.

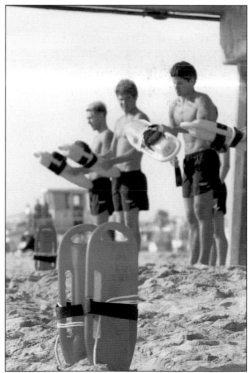

Lifeguard Phil Navarro caught this poignant shot of training cadets wrapping their bright yellow rescue cans as one of them eyes the coveted red rescue can. Until a cadet makes it through training, they are not to carry the red can that is used by those who have successfully graduated from the lifeguard training academy. Graduation from the academy is one of the most cherished memories of becoming a full-fledged lifeguard.

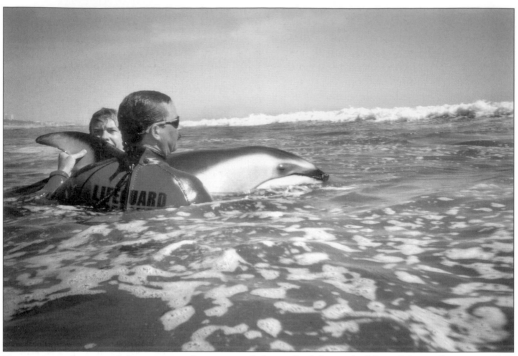

Protection of marine life is among the responsibilities for lifeguards. Here, lifeguard captain Kirk Thomas (front) and Sam Bertolet (back) assist a dolphin in its attempt to get back out to sea.

Despite all the technological breakthroughs in ocean lifesaving equipment, nothing can replace the eyes of the lifeguard in spotting a victim in trouble. Here, lifeguard Jeremy Simpkins watches over bathers.